John Steer
was born in Dorset in 1928,
and educated at Keble College, Oxford, and the Courtauld
Institute of Art. His first post was as Assistant in the City Art
Gallery, Birmingham; he subsequently held lectureships at
the Universities of Glasgow and Bristol. In 1967 he became
the first Professor of Fine Arts at the University of St
Andrews, starting a new department. From 1980 until 1984
he was Professor of Art History at Birkbeck College,
University of London, and is now Emeritus Professor of the
History of Art, University of London. He was a member of
the Executive Committee of the *The Genius of Venice*
exhibition at the Royal Academy in 1983–1984. Previous
publications include *Alvise Vivarini*, 1982.

WORLD OF ART

This famous series
provides the widest available
range of illustrated books on art in all its aspects.
If you would like to receive a complete list
of titles in print please write to:
THAMES AND HUDSON
30 Bloomsbury Street, London WC1B 3QP
In the United States please write to:
THAMES AND HUDSON INC.
500 Fifth Avenue, New York, New York 10110

Printed in Singapore

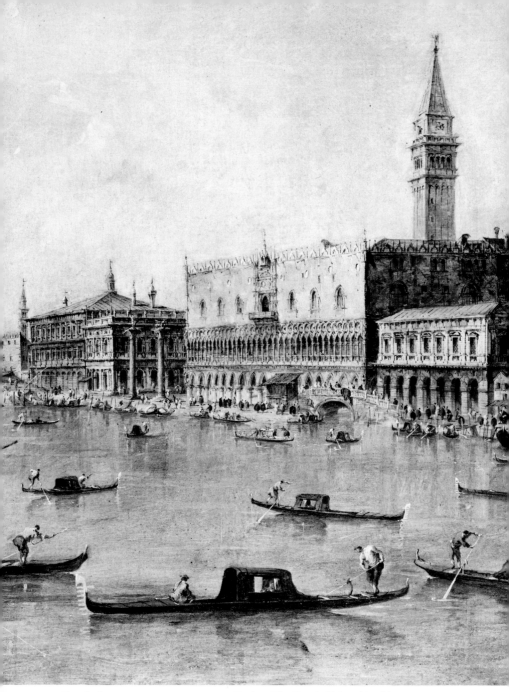

Frontispiece: FRANCESCO GUARDI *Venice: The Doge's Palace (detail)*

Venetian Painting

A Concise History

John Steer

175 illustrations, 33 in color

Thames and Hudson

TO ANNE HEWER

I am deeply grateful to Professor Johannes Wilde, who first caused me to look seriously at Venetian painting, and whose ideas and feeling for it constantly colour this book. I am also grateful to my friend David Salter, who read much of the manuscript and made many helpful suggestions.

© 1970 Thames and Hudson Ltd, London

First published in paperback in the United States of America in 1986 by Thames and Hudson Inc., 500 Fifth Avenue, New York, New York 10110
Reprinted 1993

Library of Congress Catalog Card Number 79–66134

ISBN 0–500–20101–3

Printed and bound in Singapore

Contents

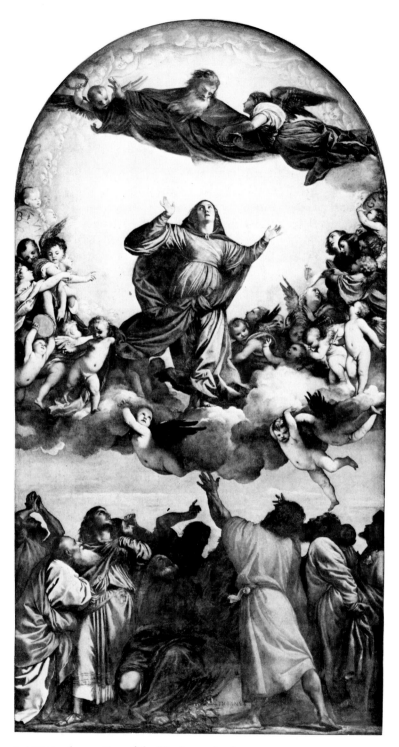

1 TITIAN *Assumption of the Virgin* 1516–18

Introduction

In looking for the characteristic qualities of the Venetian school – the 'Venetian-ness of Venetian art' – we may begin with a familiar comparison. The contrast between the so-called 'sculptural' style of Central Italy and the so-called 'painterly' style of Venice is one of the truisms of art history, but the *Transfiguration* of Raphael and the *Assumption of the Virgin* of Titian, *Ills. 1, 2* still make, across the page, a revealing contrast, which may help to clarify the theme of this book. The two works were painted within a few years of each other, in the period 1516–20, and the differences between them are more rather than less striking, because of some superficially Venetian elements which Raphael, great eclectic that he was, had by then absorbed into his essentially Roman style.

Both paintings are, of course, in the grand manner: heroic in scale and conception. A vocabulary of forceful movements and large gestures conveys the sense of morally exalted persons engaged in great events. In each the subject is clearly stated and the composition closely knit together. The upper and lower halves of the paintings are linked by the movements and gestures of the figures, which, although grandly rhetorical, have always a natural motivation. Form and content are one, and both works have that internal balance and organic unity of parts which makes the High Renaissance a normative period in the history of European art.

Raphael supposes two viewpoints in his painting: one for each of the two scenes – the Apostles with the epileptic below, the Transfiguration above – which both appear to be looked at from eye-level. This allows him to dispose the figures in both halves clearly on the ground and to avoid violent foreshortenings, which would distort their noble forms. He is concerned

7

not so much with an effect of immediate reality as with a lucid portrayal of the action, which will convey its essentials as clearly as possible. The drama of the scene, although vigorously expressed, is carefully controlled to serve this end.

Titian's approach is very different. All the figures in his painting are seen from the same viewpoint. We seem to be looking at them from slightly below; those at the back are hidden by those in front, and by movement and gesture our eyes are carried up and between them to the ascending figure of the Madonna. Of course, Titian's scene is not correct in every detail (it is not an illusion), but it creates a true visual sensation: a feeling of space as it is actually seen and of the sacred events as something taking place in our world into which we are swept up and in which we emotionally participate.

The difference can be summed up by saying that whereas Titian's world is immediate and empirical, Raphael's is conceptual and of the mind. The statement needs qualification, but the contrast, which it implies, is a true one and can be seen in details as well as in the whole. Each of Raphael's figures is thought of as a separate unit, and brought together they are like group sculpture. Even when only a small part of a body is showing – in the heads, for example, at the back of the picture on the right-hand side – the rest of the body is implied, because Raphael's space is so clearly constructed that it creates a vacuum which the figure must be conceived as filling.

The very strong light, which certainly shows Venetian influence, creates a unifying effect of light and shade, but because Raphael, wherever possible, makes it fall along the forms in order to explain their volume, it clarifies rather than breaks up the figures. Light indeed is conceived not as the creator of form, but as something applied to form already existing, and it is this conception that is at the root of Raphael's whole idea of art. For him form is primary, and colour, light, and shadow are only additional elements, added to it. For Titian, on the other hand, light and shade are the revealers of form, and colour the substance from which it is made.

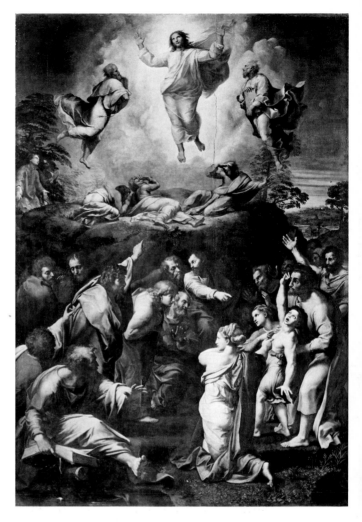

2 RAPHAEL
Transfiguration
c. 1517–20. One of
Raphael's last works

In the *Assumption*, the group of Apostles, silhouetted against
the sky, is created, by strong cross illumination, from patches
of light and shade. So strong is this pattern that when our atten-
tion is not deliberately concentrated, the forms are partly lost
in it, and it is only by conscious effort that we attach the
gesticulating limbs to individual bodies. The grouping has some
of the vital confusion of life itself, and there are marvellous
passages of direct observation, such as the hand of the pointing

9

figure in the background, half flattened against the sky, half modelled by touches of light. The contrast between this and the perfectly foreshortened, eminently sculptural hand of the pointing Apostle on the left of Raphael's painting effectively sums up the difference between the two artists in their attitude to form.

In Titian, and in the Venetian school as a whole, this sensuous approach to visual data is matched by a comparable approach to paint itself. In order to record these effects, Titian immensely extends the possibilities of the oil medium which he is using, and, as a corollary, develops his feeling for the medium itself. A love of colour and texture in the thing seen has its natural complement in a similar love for the sensuous qualities of the medium in which it is recorded; and a feeling for paint, for the texture and surface of the canvas and the decorative pattern of the brush-strokes on it, is an essential element in Venetian art.

Venetian painting, then, is about colour, light, and space, and only secondarily about form. It can be called visual in a special sense, because colour and light and shade are, in fact, the raw materials of visual experience, and Venetian painters of the sixteenth century found the means of recording with paint the way in which we perceive them in the eye. They also found in oil-paint a medium of immense range and potentiality in which they could express their love of colour and texture for their own sakes. All these characteristics have their origins in an artistic tradition going back to Byzantium, and they continue as the main themes of Venetian art into the eighteenth century. They are, therefore, the main subject-matter of this book.

Why did Venetian painting happen in Venice and nowhere else? The question in this bald form can never be answered, but at least we can see, in the tradition from which Venetian art sprang and the nature of the environment in which her artists lived, some of the things which made this development possible.

All Italian painting down to the thirteenth century, of course, was to a greater or lesser degree subject to the influence of Byzantine art, and all Italian local schools were provincial variants of the central Byzantine tradition, as Vasari saw when he described them as being in the *maniera greca*. But Venice, as the chief commercial link between Byzantium and Western Europe, received Byzantine art in a purer, richer, and more concentrated form. Down to the fourteenth century the mosaics of S. Marco show fairly quickly the effect of stylistic developments in the art of Byzantium itself and Byzantine objects of the first quality constantly reached the city.

This was especially the case after the Sack of Constantinople by the Crusaders in 1204. The Treasury of S. Marco is rich with objects that arrived at about that time. The Pala d'Oro itself, which stands behind the high altar and is consequently the most important piece of ecclesiastical furniture in the city, was originally executed by Byzantine artists, although with Venetian collaboration, shortly before 1105, but was enriched and enlarged in the early thirteenth century by panels from the destroyed Church of the Pantokrater in Constantinople, which were almost certainly brought to Venice at the time of the Sack.

No work shows better the physical richness of Byzantine art, which is the background to Venetian painting. The Pala is enclosed in a gold frame and encrusted with jewels. The individual enamels are brilliant and translucent in colour, and the scenes and figures are built like a jigsaw from a fretwork of differently coloured patches, held together by a filigree of gold. The colours are half decorative, half naturalistic. In St Matthew *Ill. 3* the flesh-tones are delicate pink but the beard is blue, and the draperies are lined and striped in contrasting colours and dotted with inlaid patterns of red and gold. At close range each scene and figure is easily readable, but at a distance the colours all fuse together into a dazzlingly variegated surface, rich and splendid for its own sake.

The same fusion of the decorative and the descriptive is, of course, characteristic of mosaic, the chief medium in the

decoration of Byzantine churches. In mosaic, each of the tesserae from which the work is made is a separate segment of colour, and the whole image is built up from these material segments, so that, whatever its representational content, the decorative qualities of the medium are never lost sight of. The image is made up from juxtaposed rows of tesserae of similar or differing colours, applied, in the finest examples, with the subtlest intuitive understanding of the science of colour and richly modulated by the slight variations of colour in the individual tesserae and the different angles at which they catch the light.

In the first decades of the fourteenth century a final flowering of the Byzantine tradition produced the mosaics of Kariye Camii, the Church of the Saviour in Chora at Constantinople. These are the finest surviving examples of what seems to have been a last renascence of Byzantine art, which took place under the Palaeologus Emperors, after the expulsion of the Latins in 1261, and in the context of the future development of Venetian painting it is significant that they are not only extremely decorative, but use colour representationally to evoke space and light. Their colours are soft and luminous, and the glowing *Ill. 4* pinks and blues of the roofs in a detail of the *Return from Egypt* reminds one of the background of Bellini's *Virgin and Child Ill. 54 with St John and a Female Saint*, painted three centuries later. It is this sense of the spatial and light-evoking possibilities of colour, as well as its purely decorative beauty, which, as developed in a Renaissance setting, is central to the Venetian school. More immediately the Kariye Camii mosaics directly influenced the mosaics of the *Life of St John the Baptist* in the Baptistery of S. Marco, which, although less brilliant than their Byzantine models, are none the less subtly modulated in colour and show a lively and sophisticated narrative technique.

The other fundamental, but less tangible, influence on the development of the Venetian school of painting is the city herself. Built on water, she is a city whose visual effects are, from the very nature of the dominant medium, changing and

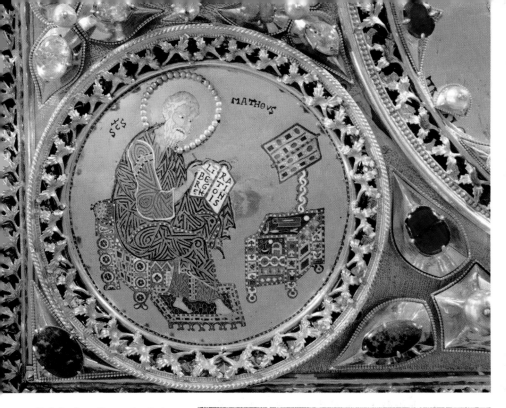

3 *St Matthew* from the Pala
d'Oro, a typical enamel
from this exceptionally
splendid composite
altarpiece

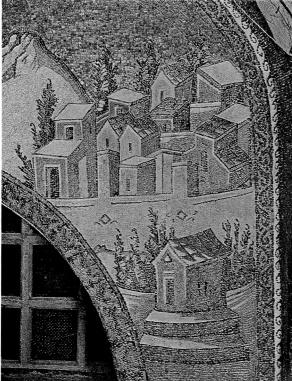

4 Detail of the *Return from
Egypt*, at Kariye Camii,
beginning of fourteenth
century. These mosaics are
the latest and most
complete cycle of
Byzantine mosaics to
survive in Constantinople

shifting. The atmosphere is softened by evaporation, and the surfaces of the buildings, eroded and made porous by salt, seem often to be absorbed in light to the point of dissolution. The effect of environment on painting is, of course, fundamental, and in the work, for example, of Piero della Francesca it is easy to see, not only that he illustrates the Umbrian landscape directly, but that his whole lucid and orderly sense of space is related to its visual qualities. Similarly, Venetian painters brought up in the city, or, like Titian, arriving there from the mountains of the Veneto, from a landscape in which the light is constantly changing, the contrasts dramatic, and the colour strong, started from a sense of space more ambiguous and colouristic and a sense of form less permanent and defined than was the case with the artists of Tuscany and Central Italy. The painters of Venice only rarely illustrated their city, and when they did they tended to seize on its permanent characteristics rather than its flux; but its unique visual qualities entered into their whole way of seeing and, fused with the decorative traditions inherited from Byzantium, determined the direction which Venetian painting took. The constantly moving pattern of coloured reflections in the Venetian canals surely, for example, inspired the changing surfaces and shifting colours in the painting of Veronese, just as the Pala d'Oro must have stimulated his love of decoration. It was from this dialogue between tradition and environment that Venetian painting was born.

The Trecento and the early fifteenth century

Paolo Veneziano was the founder of the Venetian school. This is not to say that there had not been painting in Venice before. There are the remains of a cycle of hieratic, Romanesque frescoes of high quality in SS. Apostoli and the fragments of a gracious, more sophisticated cycle in S. Zan Degola; but Paolo, like Cimabue and Duccio in Florence and Siena, is the first artist with a rounded, discoverable personality whose style and development can be charted and discussed.

His date of birth is not known, but there is a polyptych, of 1321 at Dignano in Istria, which is fairly certainly attributed to him, and there are dated works, sometimes signed in collaboration with his sons, Luca and Giovanni, between 1333 and 1358. He seems to have died before 1362. Paolo popularized in Venice the composite altarpiece: a complex of painted scenes and figures within a richly gilded and carved frame, which, in different forms, was to be the most important element in Venetian church decoration for nearly two centuries.

The shift of emphasis from wall mosaics to these painted polyptychs is of immense psychological significance. The Holy Figures placed until now, enormous and remote, in the upper part of a building – their position indicative of their hieratic isolation – were brought down into the church and placed at the spectator's level. This was the beginning of humanization, and is part of a general reorientation of emphasis in Venetian churches. The Byzantine style was replaced, in the mid fourteenth century, by the Gothic, and the new churches, of which the most important are the churches of the Franciscan and Dominican Orders – the Frari begun in 1340 and SS. Giovanni e Paolo, of which the crossing and apse were completed in 1368 – are simple structures in the Italian Gothic style, built of

15

roseate brick, with extensive wall surfaces and narrow, tall windows giving a soft, diffused light. These churches were never decorated with fresco cycles like the churches of Tuscany and the neighbouring towns of Verona and Padua, and are not given the coherent decorative treatment characteristic of Byzantine art. Instead their plain, softly-coloured walls are encrusted with a rich profusion of different objects in a picturesque confusion characteristic of the city itself. Like Piazza S. Marco, whose more or less regular plan contains a variety of different buildings, the simple, clearly articulated surfaces of the church walls are covered, in a kind of natural order, by an arbitrary accumulation of tombs and paintings and, as a result, each work has a certain independence and internal focus instead of being subordinate to an overall scheme.

This stress on the individual work always remains characteristic of Venetian art and it is only much later – not, with rare exceptions, until the eighteenth century – that we find consistent decorative schemes in Venetian churches. For the moment carved and gilded polyptychs, each on its individual altar, were their main painted decorations; not more numerous or elaborate than the altarpieces in Florence or elsewhere, but more significant as a focus of attention, being, as they were, the most brightly-coloured objects in the church.

Perhaps it was this, together with the sense of material splendour inherited from Byzantium, which encouraged Venetian painters to give their polyptychs such exceptional decorative richness. The most striking thing about Paolo's *Ill. 7* polyptych in the Accademia is the extraordinary brilliance of its colours. A marvellous lapis-lazuli blue is spread across the whole picture and constantly shot with gold. Gold is used both as the background of the picture, and as a paint. It highlights the robes of Christ and the Virgin and, in the *Betrayal of Ill. 5 Christ*, decorates the soldier's armour. This very extensive use of gold is itself indicative of the decorative aim of Paolo's art. Elsewhere it is used much more sparingly and nearly always with symbolic intention (for instance in the robe of the

16

5 PAOLO VENEZIANO *Betrayal of Christ*, from the same polyptych as *Ill. 7*

resurrected Christ in Duccio's *Maestà*, to show the spiritual nature of his Body), rarely for purely naturalistic or decorative reasons.

The same decorative intention is apparent in the style of the *Coronation of the Virgin*, the central panel of the polyptych. *Ill. 7* The swaying fold forms, the gold lines, and the pattern of the robes cut across the spatial disposition of the figures and interlace on the surface of the picture. Christ and the Virgin seem not to be seated on their throne but to float in front of the

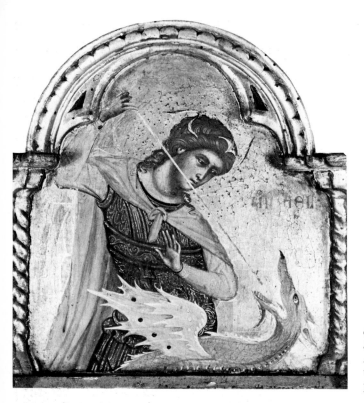

6 PAOLO VENEZIANO
*St Michael the
Archangel*,
the pinnacle of a
polyptych

richly engilded cloth behind them. As in the Pala d'Oro,
one loses consciousness of the individual scenes, even from only
a short distance away, and is aware only of the splendour of the
general effect.

Paolo's style is still Byzantine. His saints are tall, thin, and
olive-skinned, with gentle, set expressions and graceful,
eloquent gestures. Their rarefied elegance shows that styliza-
tion of the ideal art of Antiquity which had been evolved
over the centuries in the sophisticated court art of Byzantium.
One of the most perfect examples of this in Paolo's work is the
Ill. 6 half-length figure of St Michael from his Bologna polyptych,
in which an essentially organic balance of movement and ges-
ture, based ultimately on a classical understanding of human
movement, is translated into a swaying, linear pattern of the
subtlest symmetry.

18

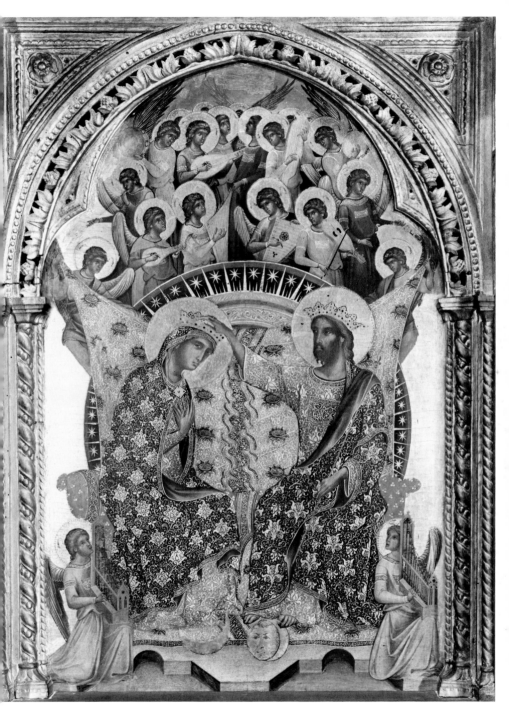

7 PAOLO VENEZIANO *Coronation of the Virgin*, centre of a polyptych probably from S. Chiara, Venice, now in the Accademia

8 *Joshua Roll*, tenth century, a Byzantine rotulus of great elegance, very likely from the Imperial scriptorium

 The nature of the debt of this style to Byzantium becomes
Ill. 8 clear by comparison with a scene from the famous *Joshua Roll*, now generally dated to the tenth century. This is an example of the Byzantine court style, which did not, as used to be thought, fall into decadence after the Sack of Byzantium by the Crusaders in 1204, but can now be seen, after the restoration work recently done in Constantinople, to have had a final flowering in the court of the Palaeologus Emperors after 1267. Many scholars now regard the humanized Byzantine style of Early Trecento Italy as a peripheral manifestation of this metropolitan revival of Byzantine art, and it has been suggested (without much evidence) that Paolo had actually visited Byzantium.
Ill. 5 Certainly a scene like the *Betrayal of Christ*, one of the side compartments of the Accademia polyptych, is derived from the tradition of the *Joshua Roll*, both in the compact grouping of the blue-helmeted figures and the easy descriptive movements and gestures by which figures like the servant in the foreground naturalistically link together the different parts of the action.

 Yet Paolo's style cannot wholly be explained by the Byzantine tradition. The decorative quality of his work is heightened by a new compactness in the grouping, and by a new lyricism in

9 PAOLO VENEZIANO *St Mark averting a Shipwreck* 1345, which Paolo signed with his sons Luca and Giovanni

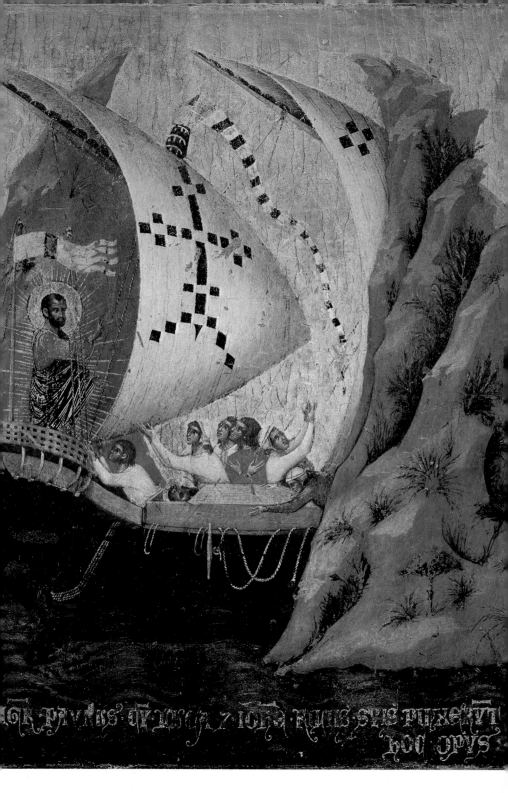

the linear design. His sense of line is sometimes already Gothic, and must be due to influences reaching Venice from the mainland, either from Siena or from the Gothic North. Paolo's style can indeed be seen in general terms as an individual synthesis of Byzantine and Gothic elements, with an increase of the Gothic strain as his art progresses. His *Madonna of Carpineta*, signed and dated 1347, is sweeter and more humane than his earlier work and looks forward to the more completely Gothic style of his successor Lorenzo Veneziano.

One expected influence, that of Giotto, is almost entirely absent from Paolo's style. Although Giotto had painted, in neighbouring Padua, one of the greatest fresco cycles of the Tuscan school, only the iconography of the scenes had much influence on Venetian art. The solidity of Giotto's figures and the clearly constructed space in which they move did not interest Venetian artists, and nothing is more indicative of the independence of the Venetian school than its almost total indifference to the stylistic message of these masterpieces.

In Paolo's work the Venetian alternative to Giotto's style is already clear, as can be seen in the narrative scenes which he painted for the cover of the Pala d'Oro. In one of these scenes in which St Mark is miraculously preserving a ship as it passes

Ill. 9 between treacherous rocks, Paolo creates by means of colour an immediate feeling of space and sea air, contrasting the deep blue-green of the sea with the warm ochre-red of the rocks. Although figures and landscape are stylized in the Byzantine manner and there is no realism of scale, we actually feel the space as the ship squeezes through the gap. She is visually cut in half by the foreground rock, but her prow already appears on the other side, and through such details, Paolo shows an approach to form and space which is direct and visual. Where Giotto creates solid figures and constructs space round them, Paolo creates space with figures in it and by the very casualness of his composition gives us a sense of nature immediately experienced. In this, his style has its roots beyond Byzantine art, in the impressionistic tradition of the painting of Antiquity itself.

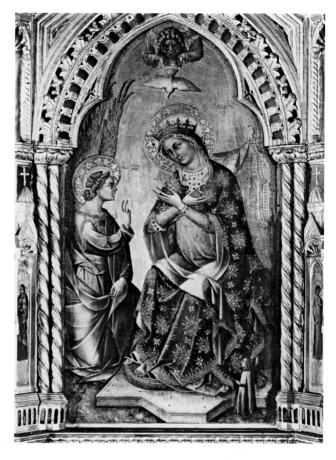

10 LORENZO VENEZIANO
Annunciation 1357, the
centre of a very
elaborate polyptych
executed for a Venetian
Senator, Domenico Lion.
It cost three hundred
ducats

The art of Lorenzo Veneziano, whose dated works run from 1356 to 1372, had its starting-point in the work of Paolo, but developed in a decisively Gothic direction. It is likely that after a period in Paolo's orbit Lorenzo visited Bologna, and also Verona, both of which were centres of Gothic art. At this time Venetian artists began to look towards the mainland, rather than to Byzantium, and this change reflects comparable developments in the political sphere, leading to the conquest, during the course of the first half of the fifteenth century, of a mainland Empire for Venice, stretching as far as Bergamo.

The *Annunciation* in Lorenzo's Lion polyptych dated 1357 *Ill. 10* has a smiling intimacy which reveals these Gothic influences.

23

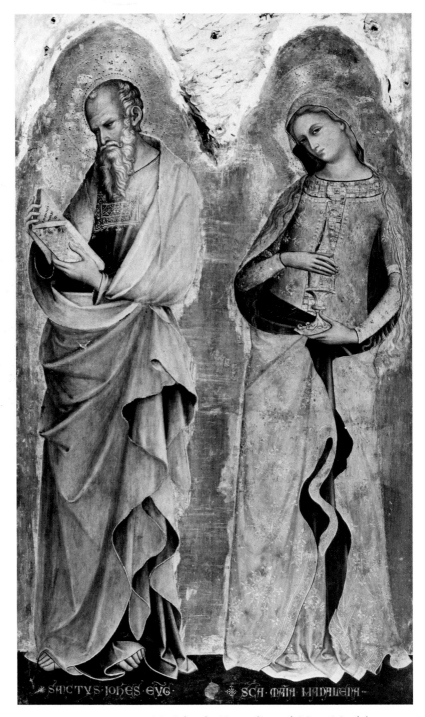

11 LORENZO VENEZIANO *SS. John the Evangelist and Mary Magdalen* 1357, from the Lion polyptych

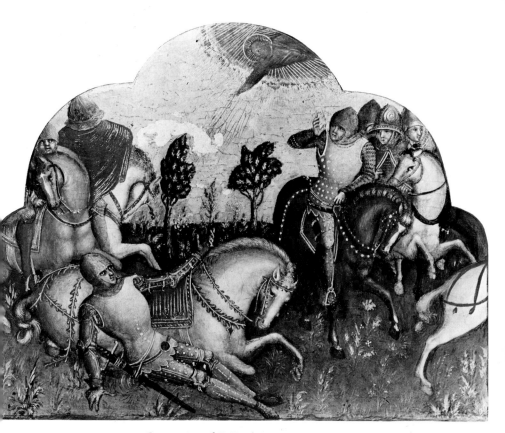

12 LORENZO VENEZIANO *Conversion of St Paul* 1369

The style is more three-dimensional than Paolo's, the colour bright and Gothic rather than rich and Byzantine. Grass-green and scarlet are the favourite colours of Lorenzo and they appear also in the tall Saints at the side of the polyptych who, although they still keep the proportions of Paolo's figures, have fuller, more realistic draperies which envelop the body and fall in the echoing, cup-like folds so often to be seen in northern Gothic statues. Gold has almost disappeared, except as a background, and the gilded brocade patterns punched into the robes of the female figures are carefully foreshortened.

 Ill. 11

This style aims at the presentation of an idealized but physically real presence to the devout, and is an expression in painting

25

of the new, intimate type of devotion first popularized by the Franciscans and developed throughout the fourteenth century in Siena and elsewhere in Central Italy. This kind of devotion sought to achieve a more personal relationship between the individual and God, and developed an imagery of highly emotional scenes in which the Saints or the Virgin are shown with touching intimacy.

The same intimacy is present in Lorenzo's small narrative scenes, such as the five predella panels of 1369, now in Berlin. In characteristically Gothic fashion, the 'dramatis personae' of *Ill. 12* St Paul's conversion are treated as a group of medieval knights in a flowered meadow, but the narrative content is conveyed with unusual visual vividness. Half of a disappearing horse is shown on the right, a man's head disappears into his cloak, and the trees in the background seem to react in agitation to the event. The immediacy of Paolo's narrative style is here preserved and brought up to date, and the involvement of nature in the drama looks forward, in an unexpected way, to much later developments in Venetian art.

From this point, until the middle of the fifteenth century, Venice remained constantly open to outside influence and her painting followed the general development of Gothic art, which reached her either from Central Italy or from beyond the Alps. As early as 1352 Tommaso of Modena had finished a series of typically Gothic frescoes in S. Nicola at Treviso, in which the Saints are represented in bright colours and fashionable costumes, and this type of work had considerable influence in Venice. Not especially fashionable, but typical of this imported *Ill. 14* style, is the *Madonna of Humility* by Giovanni da Bologna (in the Accademia), a subject which is Sienese in origin and often treated in Venice at this period. The members of the Scuola di S. Giovanni Evangelista, one of a number of those corporations or religious clubs for laymen which were such an important feature of Venetian life, here kneel at the Virgin's feet and put themselves under her protection. This is typical of that immediate relationship which was now felt between

26

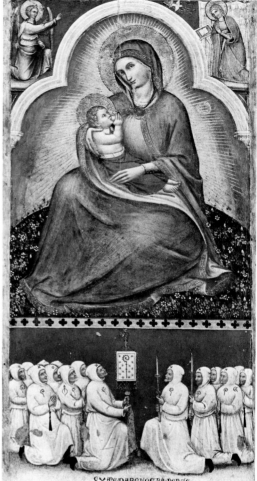

13 NICOLO DA PIETRO *Madonna
Enthroned with Music-making Angels*
1394

14 GIOVANNI DA BOLOGNA *Madonna of
Humility*

the faithful and the Madonna seen in some specially venerated aspect of her manifold role as Mother of God and co-redemptrix with Christ. Likewise intimate, and this time probably showing the influence of Bohemian Gothic painting, is the *Madonna Enthroned with Music-making Angels*, signed and dated 1394, by Nicolo da Pietro, in which the elaborate architectural throne and the detached, almost sculptural angels have a decidedly northern look.

Ill. 13

27

The dependence of Venice on outside influence at this period is especially apparent in fresco painting, in which she did not produce a native school. Both Padua and Verona, which came under Venetian government in 1405, had produced flourishing traditions of fresco painting, and when fresco painters were needed in Venice they were imported. This was perhaps due to the paucity of commissions, for, as we have seen, it was not the fashion to decorate Venetian churches with frescoes. But this scarcity of fresco painting must be attributed to taste rather than, as is sometimes done, to the unsuitability of the climate for the medium, since the Venetians were perfectly prepared to decorate the outside of the buildings in fresco – where they were so exposed to the elements that practically none of them has survived – and the most important of all State commissions, the paintings in the Palazzo Ducale, were originally in that medium. The foremost of the frescoes in the Palazzo Ducale was a vast painting of the *Coronation of the Virgin* by the Paduan Guariento, painted between 1365 and

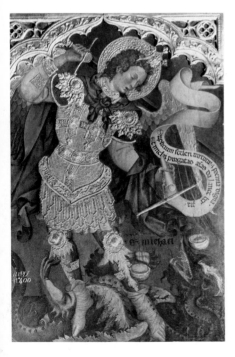

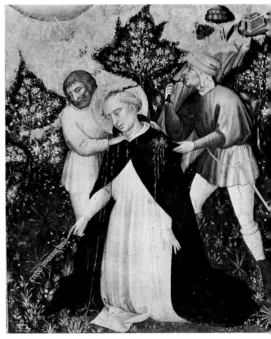

17 JACOBELLO DEL FIORE *Coronation of the Virgin* 1438

1368 on the short wall of the Sala del Maggior Consiglio above the benches of the Doge and the Signoria, in the position now occupied by the *Paradise* of Tintoretto. When the *Paradise* was taken down in 1903 large fragments of Guariento's fresco were found to have survived and these are now shown in a neighbouring room.

The *Coronation* was placed in the middle of a many-tiered Gothic structure of great richness and elaboration, and had the heraldic balance of a courtly ceremonial. This heraldic side of Gothic art must have appealed especially to the ritual-loving Venetians, whose corporate identity was, from early years to the fall of the Republic, expressed in elaborate ceremonial processions and displays. It takes root in native art in the painting of Jacobello del Fiore (working 1394, died 1439), one of whose last works is in fact a rather stiff and formalized version of

Ill. 17

29

Guariento's *Coronation* painted in 1438 for the Council Hall of Ceneda, a Friulian dependency of Venice, and now in the Accademia.

Ill. 15

Jacobello is not a great painter, but his style admirably fits its purpose. His *St Michael* shows the dark rich heraldic blues and reds which he preferred, as well as the elaborate use of embossed gold in the armour, which is built up in gilded gesso and stands out in relief from the panel. It also shows the taste for extremely elaborate convoluted forms, which twist and combine on the surface: the scroll, the wriggling dragon, and the silhouette of the Saint himself. The same taste can be seen in the elaborate, rich borders of stylized leaves, either carved in stone or modelled in terracotta, which surround the Gothic doorways of Venetian churches and proliferate over their walls as the borders of tombs. Not all Jacobello's paintings

Ill. 16

are ceremonial. The second shown is in theory a dramatic scene. It depicts the assassination of the Dominican Peter Martyr, murdered by brigands only a few years before, and one of a number of itinerant preachers of the Franciscan and Dominican Orders who inspired such devotion among the populace that they were canonized in popular imagination almost immediately after their deaths. Even so the drama is very muted. The murder takes place not in the wood of the story, but in a flowered meadow of a kind beloved by Late Gothic art, in which every flower is treated in detail and inscribed on the flat of the gesso ground like a pattern on a carpet. In one way the figures are much more realistic than those of Lorenzo Veneziano's *Conversion of St Paul* half a century before; their proportions are more true to life, they are modelled by light, and their features are individualized. But it is an anecdotal realism only: the dramatic impact of the scene which so concerned Lorenzo is not conveyed by Jacobello at all. This delight in detail and avoidance of drama is typical of the International Gothic style, which was essentially a court art, secular in feeling and gay in mood. Its greatest Italian exponent was Gentile de Fabriano (*c.* 1370–1427), who moved at this

30

time from one Italian city to another and in 1409, early in his career, was in Venice painting frescoes in the Palazzo Ducale.

These frescoes, begun by Gentile and carried on by his pupil, the Veronese Pisanello, were certainly the most famous works of art in Venice during the first half of the fifteenth century. The historian Fazio, writing in Naples in the late 1450s, singles them out for special praise and describes particularly, in a fresco by Pisanello, 'a great company of court officials showing a German dress and cast of countenance: a priest distorting his face with his fingers, and boys laughing at this with such delight as to excite merriment in those who view the picture'. It was this kind of skilful, naturalistic effect that delighted the admirers of International Gothic art, and there is no doubt that such things were now being enjoyed for their own sake. Fazio makes this very clear when he speaks of a fresco by Gentile of 'a hurricane uprooting trees and other like objects', which puts 'fear and dread' in those who see the picture.

The subjects of the Palazzo Ducale frescoes were in fact semi-secular, showing the conflict between Pope Alexander III and Frederick Barbarossa and the reconciliation brought about between them by the Doge of Venice. They constituted a new kind of historical cycle, indicative of the particular local pride of the Venetians and their conviction of the importance of their city, and set the pattern both for subsequent historical cycles in the palace and for the secular tone of much Venetian decorative painting. Unfortunately, all the frescoes of this date in the Palazzo Ducale are destroyed without any record, and to get some idea of what they were like, we can only look at the fresco from the history of St George by Pisanello on an *Ill. 18* arch in Sant' Anastasia, Verona, which shows that combination of realism of detail and atmospheric effect with a general spacelessness so typical of International Gothic art.

Only one native Venetian artist, Michele Giambono (active 1420–62), made something of his own from the International Gothic style of Gentile and Pisanello. His *S. Chrisogono on*

31

Ill. 19 *Horseback* is typical in style and in subject of International Gothic. The youthful, curly-headed figure occurs again and again in International Gothic art and the armoured Saint with his brocaded cloak and richly-caparisoned horse is the ideal knight of chivalry. As in Pisanello's fresco, and by implication in Gentile's, there is a great beauty of atmospheric effect. The softly modelled forms of the horse glow white against the dark green of the trees whose trunks catch the light. Above, the gold ground is transformed, by the *contre-jour* effect of the dark trees against it, into a glowing, atmospheric sky. The twisting forms of the pennant and the mobile silhouette of the horse and rider belong to the same decorative world as the heraldic painting of Jacobello del Fiore, but the tense pose of the Saint and the emotive effect of atmosphere give a new emotional force to the painting, which is reflected also in the nervousness of the Saint's expression. This Saint has temperament in a way Pisanello's has not and in this context every change and flicker of contour acquires a nervous intensity which makes the *S. Chrisogono* a highly affecting work of art.

18 PISANELLO *St George* 1438–42, a fresco painted over an arch in Sant' Anastasia, Verona

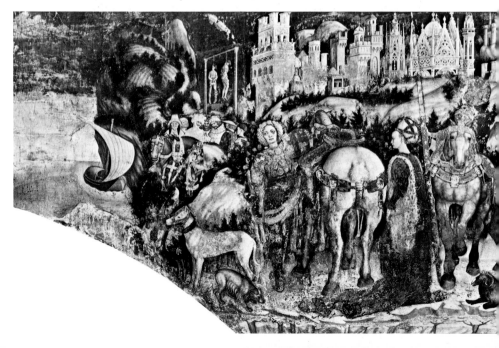

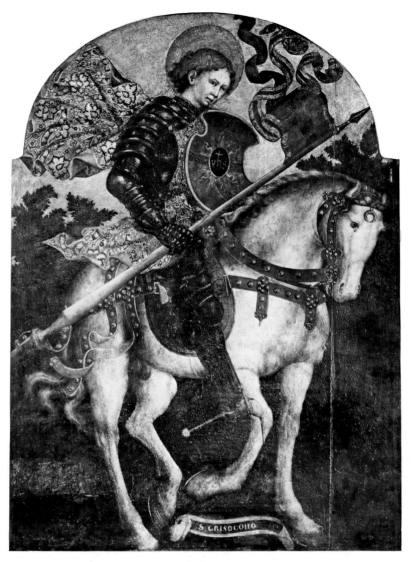

19 MICHELE GIAMBONO *S. Chrisogono on Horseback*

The same nervous inner life also informs the saints in the various polyptychs of Giambono. In his works the courtly style is transformed by a new emotional force, and he alone of Venetian artists has something of the subjective intensity of the Late Gothic art of the North.

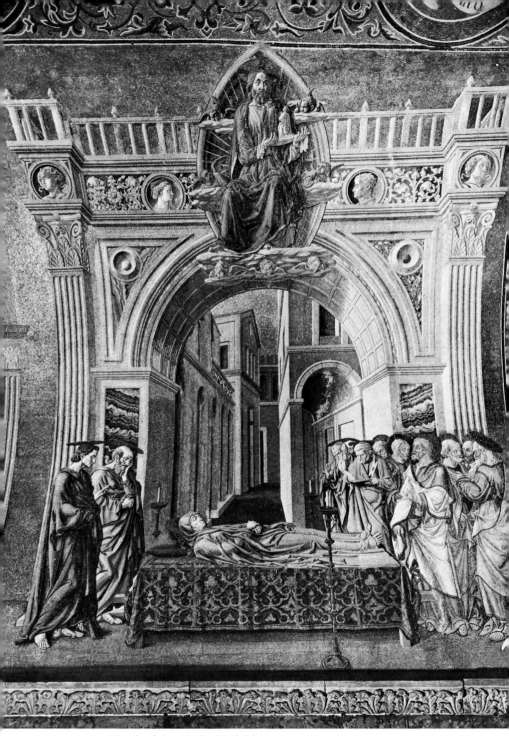

20 *Death of the Virgin*. Mid fifteenth century

The Early Renaissance in Venice

By about 1440, when Giambono was in mid-career, most of the masterpieces of Florentine Quattrocento art had already been created. The Venetian Renaissance lags far behind and the task of Venetian artists in the second half of the fifteenth century was not only to absorb what had happened in Tuscany, but also to create a national school out of the still international style of the preceding decades. What they, or more specifically Giovanni Bellini, astonishingly achieved, was an independent Renaissance style, which 'rediscovered the world and man' in a way parallel to, but different from, that of Central Italy. By the end of the fifteenth century a Venetian style had developed, which equalled in originality, quality, and historical importance the greatest achievements of Central Italian Renaissance art.

But at the beginning of this period the works by Florentines available in North Italy provided a criterion by which the Gothic style of Gentile and his followers could be judged and found wanting. Donatello was at Padua, working on the Santo altar, between 1443 and 1453; Uccello, very early in his career, worked on the mosaics of S. Marco; and in 1444 Andrea Castagno signed a series of frescoed figures in the apse of S. Tarasio, the chapel of a convent attached to the Church of S. Zaccaria in Venice.

Of these early Tuscan-style works, the most readily visible in Venice was certainly the mosaic of the *Death of the Virgin* *Ill. 20* in the Capella Mascoli in S. Marco. This mosaic, which is contiguous on the vault to mosaics by Giambono, differs from earlier Venetian work in the use of a focused perspective in which all the lines recede to a single vanishing-point. As is well known, this new device was discovered by Brunelleschi in Florence, in about 1400, and provided, as International

Gothic art had not, a coherent method of creating the illusion of space on a flat surface. Its theoretical aim was to allow for an optically consistent re-creation of the visible world, and since its method could be expressed mathematically, it gave the intellectual Florentines the opportunity to organize their observations of visual reality on a measurable and systematic basis.

This mathematical aspect of perspective never greatly appealed to the Venetians. It was too theoretical: a construction which could be worked out in the abstract but which was not necessarily related to the realities of visual experience as they saw them. They accepted its rational understanding of the way objects diminish in size in depth, and delighted, especially at the beginning, in the opportunity it gave for bizarre optical effects. But even while they used it, they retained their own consciousness of space as something immediately seen and felt – the kind of experience conveyed by Paolo Veneziano in his *St Mark averting a Shipwreck* – and it was that they developed in the more spatially consistent terms of Renaissance art.

Ill. 9

In the Mascoli *Death of the Virgin*, perspective is already employed in a fairly sophisticated way and the mosaic is not likely to be by a native Venetian, but there has been much dispute about its authorship, both Paolo Uccello and Andrea Castagno having been proposed, among others, as its creators. Whatever its authorship, it introduces a mature Tuscan style into a leading site in Venice at an early date. The perspective is convincingly handled, the architecture monumental, orderly, and classical in style, and the figures dignified and grand. With their grave gestures, simple draperies, and solid forms, they bring to mind the figure style of Masaccio and Donatello, and the mosaic as a whole introduced to the still-Gothic world of Venetian art a new classical sobriety of form and a new realism of movement and expression.

Two families, the Vivarini and the Bellini, dominate Venetian Quattrocento painting. Of these the Bellini are, in the long run,

the more important; but perhaps only because the early works of Jacopo Bellini are lost, it is in the work of Antonio Vivarini, the eldest of the Vivarini family, that we can first see a decisive break with the Gothic style. It would be wrong to describe Antonio as a Renaissance artist, yet he introduced into Venetian art new, visual principles which were fundamental to its future development.

Antonio's first surviving works date from the early 1440s, and he went on painting until at least 1467. He built up a flourishing workshop which produced gilded and painted polyptychs in large numbers for a wide range of places within the Venetian Empire and outside it. The products of his workshop and those of his brother and son were to be found in Istria, the Marches, Puglia, and even in the independent city of Bologna. Particularly in his later years the quality of his work is in direct ratio to the importance of the commission. His workshop was very much a business affair.

Obviously a large number of quasi-artisan assistants, such as were present in all the workshops of the period, worked with Antonio, but he had two main collaborators: first Giovanni d'Allemagna, a somewhat shadowy figure, and then his own brother Bartolommeo, who first modernized the family style in the mid fifties and then seems to have become independent. The family business was finally inherited by Antonio's son Alvise, who continued the Vivarini tradition until the end of the century. He was a fully Renaissance artist, much influenced by Giovanni Bellini, and because of this belongs to the later part of this chapter.

In Antonio's early works, solid figures, consistently modelled by light, are gently enveloped in a soft atmosphere, as though pressurized by cotton wool. The decorative line and the strong contrasts of tone characteristic of International Gothic art are gone. In the works of Pisanello the bright, beautifully-coloured naturalistic details were fragmentarily set against their dark green background, like jewels in a setting. In Antonio's work the colours are brighter and purer, but modified by light

37

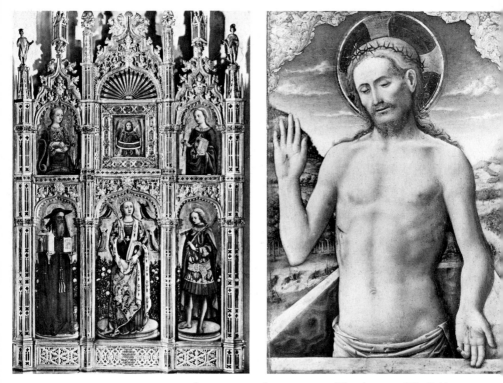

21 ANTONIO VIVARINI and GIOVANNI D'ALLEMAGNA *The Ancona of S. Sabina* 1443
22 ANTONIO VIVARINI *Dead Christ* 1445–6

they become one with their environment. Figures and space are a whole.

 This can be seen in his early polyptych at Parenzo in Istria *Ill. 22* and in the *Dead Christ* at Bologna, almost certainly an early work. It is also present, but in a more elaborate manner, in works which, in the early forties, Antonio executed in Venice: the polyptychs for the Chapel of S. Tarasio in S. Zaccaria of *Ill. 21* 1443, whose elaborate carved and gilded frames are also typical of the kind of carved polyptych which came out of his workshop. In these Antonio had Giovanni d'Allemagna as collaborator, and it is possible that the latter was responsible for the more Gothic features – the hedges of tightly knit Gothic flowers and the passages of embossed gold on the costumes, which made the polyptychs so physically sumptuous.

38

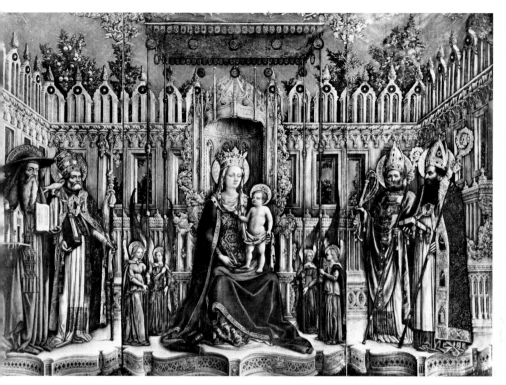

23 ANTONIO VIVARINI and GIOVANNI D'ALLEMAGNA *Madonna with Four Saints* 1446

But in fact these material splendours are always kept well in control, and the new visual principles which govern Antonio's art are nowhere more apparent than in one of the largest and most sumptuous of his works, the triptych of the *Madonna with Four Saints* for the Scuola Grande della Carità, *Ill. 23* dated 1446, on which Giovanni d'Allemagna also collaborated. Here the figures are placed, not in the confining frame of a polyptych, but in a castellated courtyard entirely consistent in its spatial construction, the golden walls of which are set against a deep blue sky. The Madonna, a monumental figure whose enveloping draperies form a plain, cone-like shape of great simplicity and grandeur, is seated, accompanied by four Saints, in the middle of a consistently created space, and the profusion of International Gothic detail is subordinated to this

39

24 FRANCESCO
DEI FRANCESCHI
*St Mammas
thrown to
the Beasts*
1445–6

unity of space and atmosphere. Above all, gold, as a metal, is
confined to the haloes and a few details of the garments. The
richly foliated throne and the background wall are not gilded,
but painted in a subtle range of yellows simulating metal so
successfully that it is some time before one realizes that they
are not in fact executed in a metallic paint. This indicates very
clearly the new optical realism of Antonio's work. Whereas
before, it was the preciousness of the metal which was of value,
now it is the artist's skilful rendering of visual experience.

Although this new emphasis on visual truth sets the scene for
the whole later development of Venetian Renaissance art, in
other respects Antonio is far from being a Renaissance artist.
Psychologically he still belongs to the Gothic world. There
is no drama and little personality in his figures: none of that

40

sense of movement and gesture as a language of psychological expression which the Florentine masters had developed, and in this respect he has sometimes been illuminatingly compared to the Florentine Masolino, who two decades earlier had likewise stood at the point of transition between Gothic and Renaissance art. Antonio also painted a series of small narrative scenes in which a number of figures are skilfully crowded into a limited space, and fragments of buildings, cut by the frame, give scale. Their narrative charm is in the manner of Venetian story-telling that goes back to Paolo Veneziano, and the casual, empirical approach to space is in the same tradition. Similar qualities can be seen in the narrative scenes of Francesco dei Franceschi (active *c.* 1447–67) whose works, closer to Inter- *Ill. 24* national Gothic than Antonio's, have an enchanting, naïve directness which makes the story quite clear, but not in the least dramatic. The one signed work of another of Antonio's followers, Antonio da Negraponte, is a delight to those who penetrate to the slightly remote church of S. Francesco della Vigna. It shows the Madonna and Child seated on an elaborate throne in which slightly fantastic Renaissance architectural forms are oddly set in a still florally-Gothic context.

By 1450, Bartolommeo Vivarini was working alongside his brother Antonio. He must have had part of his training in Padua, for his style shows almost from the beginning the sharp lines and hard surfaces which are characteristic of the pupils of the Paduan Squarcione. This style, of which the greatest master is of course Mantegna, played an important part in the development of the Venetian school in the late 1450s and 1460s, although, as will appear later, its principles were essentially alien to the Venetian tradition. Its use of line was structural rather than decorative, for it provided a means of holding together a large quantity of separately observed parts in a tight linear web. With this goes a tendency to play down the individual textures of objects, so that everything from clouds to flesh seems made of the same hard substance, as if it were made of steel or stone.

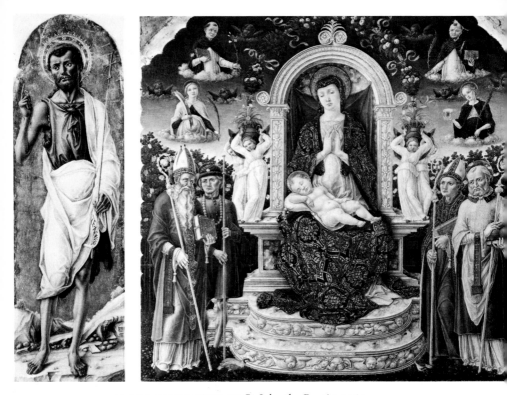

25 BARTOLOMMEO VIVARINI *St John the Baptist* 1464
26 BARTOLOMMEO VIVARINI *Virgin and Child enthroned with Saints* 1465

Ill. 25

This style was enthusiastically taken up by Bartolommeo and can be seen in his figure of *St John* for the Ca' Morosini polyptych of 1464. Within the linear skeleton, which holds the forms together, he has modelled the face in light, but the visual unity achieved by Antonio has been sacrificed to an accumulative combination of parts achieved by the essentially artificial medium of line. From this devotion to line Bartolommeo was never weaned and although, under the influence of Giovanni Bellini, he attempted, with some success, the representation of light, his style remains essentially second-hand. Despite, or perhaps because of this, he enjoyed great popularity in the sixties and seventies, and Venetian churches, notably the Frari, have a number of brightly coloured, superficially attractive

42

altarpieces from his studio, in frames which change gradually from the Gothic to the Renaissance style.

His most original achievement was to develop from his brother's triptych in the Carità the idea of the Virgin and Child with Saints in a unified space, and there are fine examples of this at Naples, dated as early as 1465, and Lussingrande, dated 1475. His pioneering of this motif, which was to become so important in Venetian painting in the last quarter of the century, anticipates, at least in the first of these two works, later developments by Giovanni Bellini and his own nephew Alvise. After the mid seventies Bartolommeo's style became out of date and he stopped getting commissions in the city itself. His late works, mostly in Bergamo, are increasingly arid and depressing.

Ill. 26

Carlo Crivelli, who was also, to use Berenson's phrase, 'formed by the Paduans', developed their use of line, with far more consistency and understanding than Bartolommeo. Delighting in its artificiality, he exploited it as an expressive force in its own right. His work was certainly a cul-de-sac as far as the main development of Venetian painting is concerned, but it has great individuality and emotional force.

The isolation of Crivelli's style is partly due to the fact that, although always proud to sign himself as Carlo Crivelli of Venice, he lived, from the late sixties at least, mainly in the Marches, possibly as a result of a Venetian court case of 1457 at which he was tried and imprisoned for adultery. The large, many-tiered altarpieces which he painted for the churches of this area, while similar to those of the Vivarini, are given a striking individuality by the intensity of his figures, so twisted and tensely coiled that they seem about to burst their frames. This tension derives partly from the strange combination in Crivelli's style of an almost aggressive plasticity with a wiry line, which inevitably denies space and stresses the surface of the painting. In the Panciatichi *Pietà* in the Museum of Fine Arts at Boston, he combines a low viewpoint and violent foreshortening with a purely decorative treatment of the back-

Ill. 27

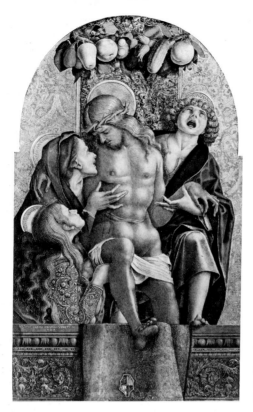

27 CARLO CRIVELLI *Pietà*
1485, the topmost panel of
a polyptych. Bellini's
Coronation (*Ill. 36*) was
topped by a similar scene

ground and very sharp outlines. The gnarled, spiky hands and
contorted expressions are details of a neurotic intensity which
turns the whole work into a hysterical cry of pain.

This intense linear style has little to do with the developing
humanism of Venice itself and, as late as 1485, when the
Panciatichi altarpiece was painted, could hardly have existed
except in the provinces. Crivelli, however, retained from his
Paduan origins a taste for Antique studies, and many details
all'antica appear in his paintings. He fully understood the
illusionistic aspects of the new perspective and used it to create
architectural settings in which bizarre, classical forms, strongly
coloured and fantastically assembled, struggle together in a
kind of jumbled surface profusion against the sense of the
perspective. The largest and most flamboyant of these scenes
Ill. 28 is the *Annunciation* in the National Gallery in London, in which

44

28 CARLO CRIVELLI *Annunciation, with St Emidius* 1486

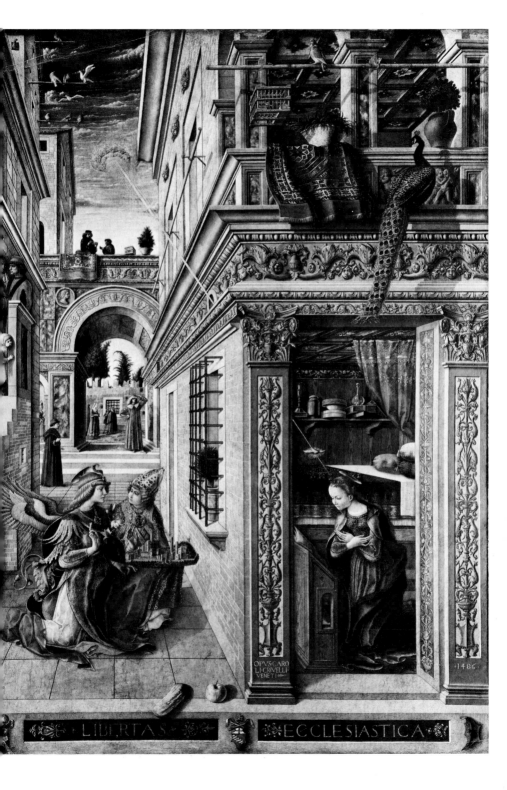

OPVS CARO
LI CRIVELLI
VENETI

·1486·

LIBERTAS · ECCLESIASTICA

he shows how artificial and how little connected with visual experience linear perspective can be. The scene is not a record of anything seen, but a construction in which a mass of separate details have been added together one upon the other and assembled according to a preconceived formula. Delightful as it is, this style has little to do with the main business of Venetian fifteenth-century art as it had, by this time, been developed by Giovanni Bellini.

Jacopo Bellini (*c.* 1400–*c.* 1470), the father of Gentile and Giovanni, was a pupil of Gentile da Fabriano – he so signed himself on a large fresco of the Crucifixion at Verona – and thus grounded in International Gothic art. Much has been made of his supposed presence with Gentile in Florence in 1423, but in fact the reference seems to be to another Jacopo with a father of a different name, and our Jacopo, whose works certainly show Florentine influence, may well only have visited Tuscany somewhat later in his life.

It is one of the tragedies of Venetian painting that so many of Jacopo's works are lost. Nothing is known of his paintings of the life of Christ and the Virgin for the Scuola di S. Giovanni Evangelista, nor of the works he painted for the Scuola di S. Marco, nor of the altar for the Gattemalata Chapel in the Santo in Padua, which in 1459 he painted with his sons. The cycles in the two Scuole seem to have been the foundation of a new type of large-scale narrative painting (presumably developed from the frescoes of Gentile da Fabriano and Pisanello), which we shall look at later in the work of Jacopo's son, Gentile. Without them, any estimate of Jacopo's own style and importance is bound to be incomplete.

That Jacopo's style was founded in International Gothic is shown by an eighteenth-century description of the great *Crucifixion* at Verona, which was dated 1436 and was in its day a work of great fame and importance. The description speaks of many figures in a rich variety of costumes, of the embossed gold on their garments and the caparisons of their horses, and

29 JACOPO BELLINI *Virgin and Child*. One of Jacopo's earlier, less severe Madonnas; that in the Louvre is still more frontal and austere

of the descriptive mottoes which came out of their mouths to help tell the story. Plainly the treatment was still rich and elaborate: far from the solid realism of Tuscan art.

In 1441 Jacopo competed with Pisanello for a portrait of Lionello d'Este and, though his winning portrait is lost, there is a picture by him of Lionello kneeling before the Virgin: a very formalized figure against a miniscule Gothic wood, which shows him working as a court artist in the International style. But in several much more severe panels of the Virgin and Child, he shows a new seriousness and simplicity and a new *Ill. 29* feeling for volume. Jacopo had clearly become aware of Tuscan art, but in the absence of dated works we do not really know at what point in his career this happened.

The sober simplicity of these Madonnas was only one side of Jacopo's mature art. His most important surviving works are two sketchbooks in the Louvre and the British Museum, the large number of drawings in which are a compound of

30 JACOPO BELLINI *Head of Hannibal presented to Prussias c.* 1450

Ills. 30, 32 perceptual truth and imaginative fancy which extend the whole range of art. Their historical importance can hardly be over-estimated and the high value they had for Jacopo's own circle is shown by the fact that in his Will, Gentile, who must have inherited them from his father, left them to his brother Giovanni only on the most stringent condition.

The sketchbooks prefigure later Venetian painting in two ways. Firstly, they treat Classical Antiquity with a freedom and fantasy which has more to do with poetry than archaeology. The buildings are fantastic in scale and bizarre in construction, as if the artist was a little intoxicated by the imaginative possi-bilities of perspective. Figures are dwarfed, and Jacopo's epic and blatantly unreal vision of Antiquity is closer to Cecil B. De Mille than to Leon Battista Alberti. Later Venetian artists did not copy Jacopo's approach to the Antique world, but they

48

31 GIOVANNI BELLINI *Crucifixion*

follow him in seeing it as a source for poetic inspiration rather than a subject for archaeological reconstruction.

Secondly, the sketchbooks record an experience of space which is as free and varied as can be imagined. The wide plains and climbing mountains of Jacopo's drawings are often extended over two pages of the sketchbooks and, though his sense of proportion is sometimes arbitrary and the bird's-eye view he takes of events often dizzy, we yet feel the distances as never before. Figures appear from between rocks, descend on winding paths through mountains, or are perilously placed on platforms of overhanging rock. All these things are brought across with the same physical directness as in Paolo Veneziano's
Ill. 9 scene from the Life of St Mark on the Pala d'Oro, where one felt the pressure of the rocks as the ship squeezed between them. But with Jacopo there is a new breadth and freedom. Perhaps no other artist until Brueghel, in his Alpine drawings, quite conveys this sense of the extremes of distance; the dwarfing wonder and physical exhilaration of scale.

It is from these beginnings, so different from the ordered and measurable space of Tuscan art, that the painting of Giovanni Bellini springs. His birth-date is unknown, but since he was living away from his father and brother by 1459 it is likely that he was born some time before 1430. He grew up at what may be described as the Paduan moment in Venetian painting, and the influence of Mantegna, Padua's greatest painter, is strong in his early work. His sister Nicolasina married Mantegna, so that there was a personal as well as an artistic connection.

None the less, from the very beginning Giovanni argues (to use a phrase of Johannes Wilde) with Mantegna's style. The standard comparison made by historians is between the two paintings of the *Agony in the Garden* by Mantegna and Bellini respectively, both probably dating from the early sixties, and now in the National Gallery. Mantegna's painting is constructed, almost like a model, in solid units which are built from an infinity of minutely observed details and held together by a line. Bellini's painting is also linear, but, following the

32 JACOPO BELLINI
Adoration of the Magi
c. 1450. A sketchbook
with such scenes was
inherited by Gentile
from his father and left
to his brother Giovanni

sketchbooks of his father, it is open, spacious, and free, with a
wonderful appreciation of the mood and behaviour of the dawn
light as it creeps across the valley. These qualities are present
too in the marvellously extended landscape of the *Crucifixion* *Ill. 31*
in the Museo Civico Correr in Venice, which positively glitters
with light. Bellini here establishes the main expressive language
of his early paintings: an analogy between the religious subject
and the mood of the landscape; so that in the Correr *Crucifixion*
the light streaming from Christ's body becomes one with the
shining surface of the lake, and the pathos of the suffering
figures is fused with our experience of the translucent space
and the immaculate morning light. In these works the visual
qualities of his father's sketchbooks are given a new consistency
and made to serve a single imaginative theme. Light is seen as
a medium of grace, and the beauty of creation reflects the
Creator.

51

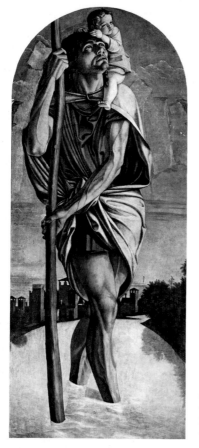

34 GIOVANNI BELLINI *Dead Christ* ▶
with St John and the Virgin

35 GIOVANNI BELLINI *Dead Christ*
with Child Angels

33 GIOVANNI BELLINI *St Christopher,*
from the polyptych on the altar of
the Scuola of St Vincent Ferrer in
SS. Giovanni e Paolo. The altar
was being constructed in 1464

Throughout the sixties Bellini constantly extended his emotional range and his means of expression. In two themes, the Virgin and Child and the Mourning over the Dead Christ, which he painted many times, he explored human emotions with a depth of humanity comparable, in the Quattrocento, only to Donatello. Colour is no longer decorative, but becomes a part of the expressive language of the picture, and in the *Ill. 34 Dead Christ with St John and the Virgin* in the Brera the cold purples and steely blues bind the figures into the chill dawn landscape, and create the mood of desolation. In the painting *Ill. 35* at Rimini, on the other hand, the colour is sweeter and the mood more tender. The dead Christ is supported by child

52

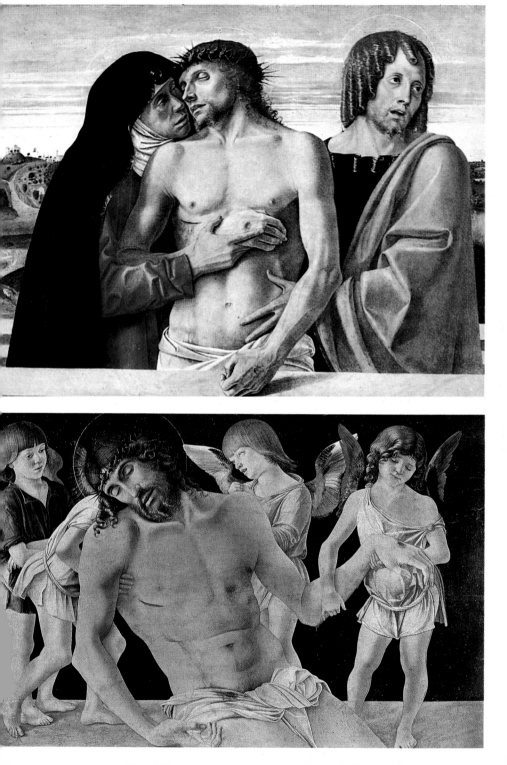

angels whose utter incomprehension has a different, more human pathos. A comparable range of feeling is found also, *Ills. 38, 39* both at this period and later, in Bellini's Virgin and Child paintings, in which he lays bare the intensely human content of the subject without losing sight of its dogmatic aspects.

The major work of this phase of Bellini's life is the altar of St Vincent Ferrer in SS. Giovanni e Paolo, which seems to have been painted shortly after 1465. It survives in its original gilded frame, which has round arches and classical pilasters in the Renaissance style and was probably the first of its kind in *Ill. 33* Venice. The figures, which seem as if carved from wood, tower over low extended landscapes and both are again gloriously transfigured by light, so that its splendour becomes the image of their immaculacy.

The polyptych has a new unity, partly because the glances of all the figures are directed upwards towards the panel with God the Father, now alas lost, which originally topped the altarpiece, and partly because of the way Bellini organizes light and colour. Instead of adding one strong colour to another in the happy, disparate confusion of a Gothic polyptych, he balances the scenes against each other – two light scenes flanking a darker one in the lower tier, two dark ones beside a lighter scene above – and creates an ordered whole. The rapt and intense devotion of each figure is a variation on a theme common to the whole altarpiece, which has a formal and dramatic integration going beyond anything which had been produced in Venice before.

In the next decades an orderly relation between the work of art and its setting is indeed an important part of Bellini's aesthetic. The ideal is a classical one and its realization is made possible by the new Renaissance style of architecture which, through the work of Pietro Lombardo, now gradually became established in Venice. The first fully developed example of this ordered relationship in Bellini's art to have survived is the *Ill. 36* *Coronation of the Virgin* in Pesaro, in which the architectural forms in the painting echo the proportions of the richly carved

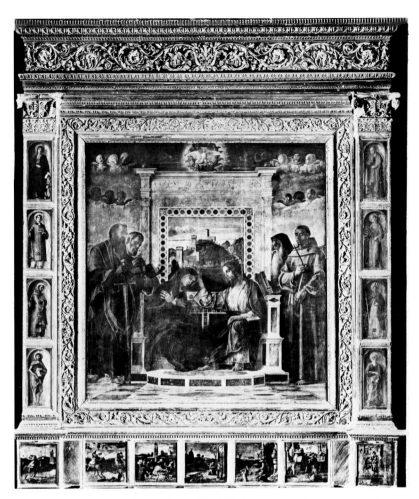

36 GIOVANNI BELLINI *Coronation of the Virgin*

frame. Even the landscape is not allowed to run wild but is controlled and contained by the square opening at the back of the throne.

The style of the *Coronation* is still linear, but Bellini has gone a long way in his argument with Mantegna's art, and the forms are broader and smoother than in his earlier works. The figures are solid and massive, like monumental sculptures, and turned at an angle to the plane to create a very three-dimensional effect.

55

Space itself looks measurable, and the clarity of the spatial structure, as well as the Albertian architecture of the throne, suggests the influence of Piero della Francesca, whose work Bellini could easily have seen if, on the way between Venice and Pesaro he visited Ferrara and Rimini, or made a detour to Urbino.

The spatial order of the *Coronation* is essential to its beauty and shows the extent to which Bellini, at this period, was influenced by Tuscan ideals. As with Piero we are hushed and held by the artist's lucid sense of interval, and the clarity of a space in which everything seems measurable and sure. But, for all its three-dimensionality, the painting is conceived in planes parallel to the surface – the frame itself, the throne, and the three towers – and the warm, emotive light, which floods the scene, so different from the translucent, Umbrian light of

37 GIOVANNI BELLINI *Transfiguration*

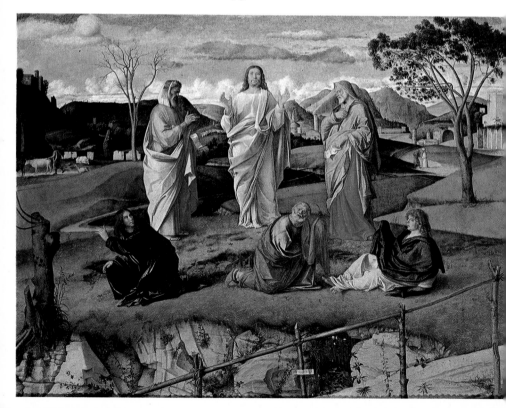

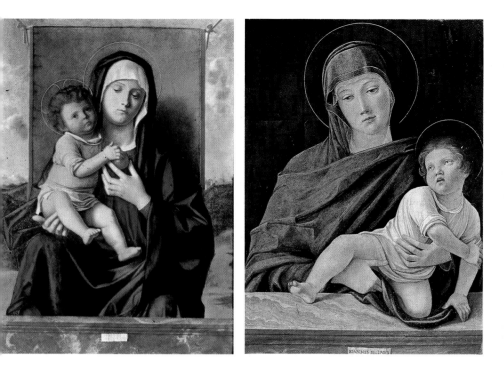

38 GIOVANNI BELLINI *Madonna of the Pomegranate*
39 GIOVANNI BELLINI *Lochis Madonna*

Piero's works, is equally Venetian. This is the most Tuscan moment of Bellini's art, but his approach to surface, colour, and light is still innately that of the Venetian tradition.

In the Pesaro *Coronation*, the humanization of what had been a hieratic subject is complete. What had once taken place in Heaven and been represented on a sculpted tympanum or the mosaic of an apse is brought down to earth to take place in the spectator's own landscape before his eyes. The throne has become a glorified garden-seat; and the rich mood of evening calm makes us feel that here is the ancestor of those pastoral scenes which were to become, in the works of Bellini and others, one of the main subjects of Venetian sixteenth-century painting. The *Coronation* is the ancestor not only of the 'Sacra Conversazione' but also of the 'poesie'.

57

To the same period, or slightly later, belongs the *Trans-*
Ill. 37 *figuration* in Naples. This is one of several scenes in which
Bellini gives landscape a new scale and importance in relation
to the figures. The figures are embedded in it and become the
focus of a re-ordered nature in which, in accordance with
Bellini's ideals at this time, the profusion of natural things is
disciplined and controlled to make a balanced whole. The
placing of the trees in the *Transfiguration* shows the same sense
of spatial interval as the architecture in the *Coronation*, but by
patches of bright colour, which appear equally in the figures
and in the distant sky and hills, he links foreground with
background, and the shining whiteness of Christ's robe be-
comes the focal centre of the whole painting. Only in Piero's
Resurrection at Sansepolcro do we find the same gathering
together of light in a single figure, and it is tempting to suppose
that Bellini had visited Sansepolcro and seen that most visually
miraculous of all Renaissance paintings.

In 1476 Antonello da Messina (*c.* 1430–79) arrived in
Venice, bringing with him the Flemish technique of oil-painting
with glazes which he had learnt in Naples. In contrast to
tempera, which is an opaque medium and can only be put on
in small, dense strokes, oil allows infinite freedom. According
to the amount of oil used, the paint can be very thick and
impasted or applied thinly in translucent glazes, almost like a
wash in watercolour. Antonello certainly gained his under-
standing of glazes from the tradition of the Van Eycks, and the
Ill. 40 lucent atmosphere of his *Crucifixion* in the National Gallery,
London, comes largely from this Flemish technique of building
up the picture in layer upon layer of transparent veils of paint.

Visually, Antonello's greatest discovery was to see forms
without the intervention of line, modelling them in light alone,
without hard edges, by the subtlest gradations of tone. At the
same time he used light to simplify the volumes in his paintings
to the perfection of geometric solids, and the intensity of his
Ill. 41 feeling for pure form, as seen for example in the *St Sebastian*
at Dresden, is comparable to that of Brancusi.

58

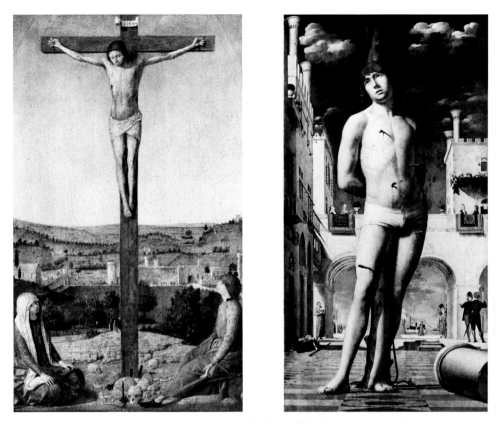

40, 41 ANTONELLO DA MESSINA *Crucifixion* (left) and *St Sebastian* (right), both pictures painted in Venice in 1474/75

Problems of dating make the exact relation of Bellini to Antonello uncertain. It is possible that Bellini was using the oil medium in some form before Antonello arrived in Venice, and that Antonello may only have encouraged him in the way he was already going. His example perhaps finally freed Bellini from the vestigial influence of Mantegna's line and suggested to him what the potentialities of the new medium were. The rounded forms of the *Madonna of the Pomegranate* in the National Gallery, London, certainly show Antonello's influence, but the strong colour harmony, red, deep blue, and bright green, is entirely Bellini's own.

Ill. 38

59

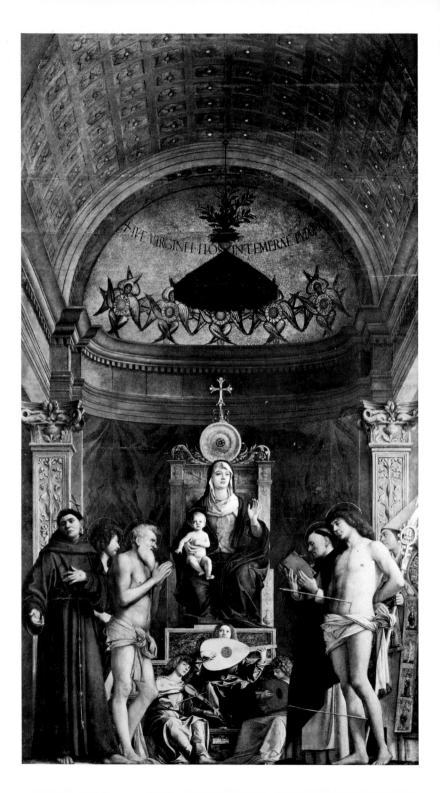

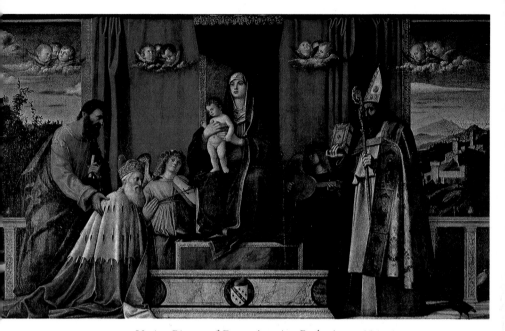

43 GIOVANNI BELLINI *Votive Picture of Doge Agostino Barbarigo* 1488

Antonello's largest painting in Venice was the high altar of
the Church of S. Cassiano in which the Virgin and Child
surrounded by Saints were painted enthroned in a domed
chapel in the Renaissance style. The classical frame of this
work was continuous with the painted architecture of the altar-
piece, so the frame and painting together formed a self-con-
tained chapel, Renaissance in its architectural style and of great
splendour, standing independently in the centre of the Gothic
church. This painting was much imitated, both in idea and
detail, by Venetian artists in the latter part of the Quattrocento
and the early years of the sixteenth century, most notably by
Cima and Alvise Vivarini.

Bellini himself had arrived at something similar when in
SS. Giovanni e Paolo he painted, on the altar next to the St
Vincent Ferrer polyptych, an altarpiece in which the Virgin
surrounded by Saints was seated in an open loggia, again
continuous with the frame. The difference in architectural form

42 GIOVANNI BELLINI *S. Giobbe altarpiece.* Probably mid eighties

between a loggia and a domed chapel suggests that the two developments were independent, but there is much dispute about this, which, in the absence of dates, cannot be completely settled. What is more important is that in both cases the form implies the same kind of humanization, the bringing of the Holy Figures down to earth which we saw in the Pesaro *Coronation*.

Such paintings are known as 'Sacre Conversazioni', because of their rapt stillness of mood, in which the Saints, scarcely looking at one another, seem to communicate at a spiritual rather than at a material level. Bellini's second 'Sacra Conversazione' is the S. Giobbe altarpiece, painted for the church of that name, but now in the Accademia. This, unlike the others, was painted for a Renaissance church so that the forms of its classically conceived architecture could be a direct continuation, suitably enriched, of those of the church itself. The viewpoint was so calculated that when the painting was *in situ* the figures seemed to be seen from the eye-level of the average spectator, and the chapel in the painting really seemed to open off the church. The Holy Figures were thus placed, palpable and real, in an extension of the spectator's own world.

Ill. 42

In parts of the S. Giobbe altarpiece there are areas of impasted paint, which show that Giovanni Bellini was beginning to grasp the possibilities of the oil medium for giving new textural richness and variety to his painting, possibilities hardly conceived of by the Flemings who initiated it. In his works of the eighties onwards, which after 1487 are often dated, Bellini becomes more and more aware of these potentialities.

Antonellesque works from the beginning of the decade, like the *Madonna of the Pomegranate* are among the most smooth and three-dimensional of his paintings. We can see, for example, at the side of the Madonna how the drapery takes the eye round the form and stresses the volume. But in the *Votive Picture of Doge Agostino Barbarigo*, dated 1488, something new happens. The forms are spread out across the plane, there are few lines leading into depth, and the outlines and edges are blurred and

Ill. 38

Ill. 43

softened. Colour too, both here and in the Frari triptych of the same year, becomes richer and more saturated and the atmosphere denser. This is the beginning of a movement in which colour and surface reassert their importance and become primary in Bellini's style. After a period of twenty years in which he had been very absorbent of outside influences, he comes back to reconsider and restate what we have seen to be the basic premises of Venetian painting. This development, which is part of the Venetian High Renaissance, will be discussed in the next chapter.

A second and independent tradition of painting co-exists with the altarpieces and devotional paintings at which we have been looking. This is the tradition of the large-scale narrative paintings which were commissioned as decorations for the Scuole, those charitable clubs of laymen which were the main focus of social life for citizens beneath the patrician class.

As has already been said, they formed a large part of the work of Jacopo Bellini, but, as everything he painted in this genre is lost, we first become familiar with them in the works of his son Gentile (active *c.* 1460, died 1507), whose speciality they also were. This kind of painting brought Gentile earlier and greater fame than that of his brother. He was made a Knight of the Empire in 1469, and, between 1479 and 1481, visited Constantinople, painting for the Sultan Mehmet II, from whom he received high honours. It was he who was first given the task of restoring and then, with Giovanni, of re-painting in oil on canvas the frescoes in the Palazzo Ducale which time had so decayed.

Gentile's narrative works are best known to us from the canvases which he painted along with others, including Lazzaro Bastiani, Benedetto Diana, and Carpaccio, for the Scuola di S. Giovanni Evangelista, and for the cycle which he executed with his brother in the Scuola di S. Marco. These works show a rather dry linear style in which line is used, not so much structurally, as to record clearly the maximum number of facts.

63

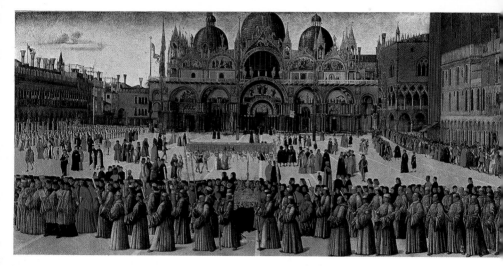

44 GENTILE BELLINI *Procession in Piazza S. Marco* 1496

The popularity of Gentile's works was undoubtedly due to their profusion of detail, to the number of portraits which they included, and to their topographical accuracy, for the Venetians, then as now, delighted in their city, and Gentile records, sometimes with love and always with accuracy, the more picturesque features of its appearance. In the *Procession in Piazza S. Marco*, for example, we are so sure that he has recorded truly the lost Byzantine mosaics on the front of S. Marco that we have no hesitation in using them as a basis for discussing the originals.

Ill. 44

The illustration opposite shows a detail from one of the S. Giovanni Evangelista canvases, in which a relic of the True Cross – the highly prized property of the Scuola – which has fallen into the canal, floats, and is rescued by a friar. A detail such as the bathing Negro on the right shows the anecdotal charm of Gentile's style, which fulfils its aim admirably without ever being visually very sophisticated.

Ill. 45

When Giovanni tackled this kind of painting, he paid much more attention to the decorative and compositional problems which are involved in holding together such a mass of disparate, visual information in a coherent way. His solution can

64

45 GENTILE BELLINI *Miracle of the Cross at Ponte di Lorenzo* (detail) 1500

be seen in the parts of the decoration for the Scuola Grande di
S. Marco, which he completed after Gentile's death. They are
much softer than those by Gentile, and all the forms tend to
fuse together into a surface pattern of colours. During the
nineties, when the bulk of his work in the Palazzo Ducale was
probably done, Giovanni must have been much preoccupied
with this kind of painting and it was perhaps in this context
that he evolved his tapestry-like late style, which was so
important for the future development of Venetian art and
which will be discussed in the next chapter.

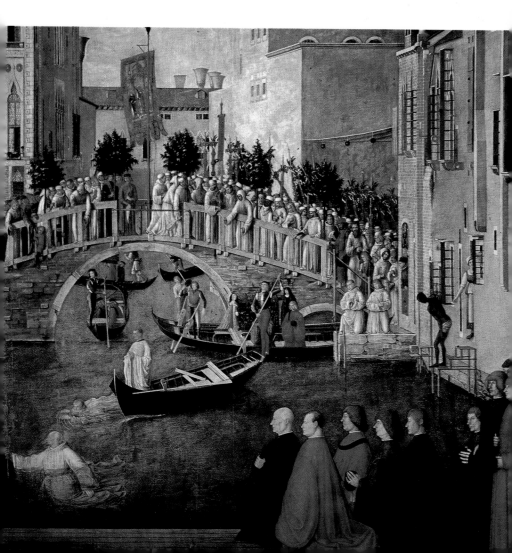

46 VITTORE CARPACCIO
*Meeting of St Ursula and
St Etherius* 1495, one of the
most sumptuous of
the scenes from the
destroyed Scuola di
S. Ursula now reassembled
in the Accademia

The style of Vittore Carpaccio (active 1490, died 1523/6) was also directed mainly at large-scale narrative paintings for the Scuole, even though he produced many altarpieces as well. Carpaccio's paintings are packed with incidents, which are spread frieze-like across the long, horizontal surfaces of his compositions. He loved story-telling, but his paintings are not dramatic and the rich settings and general effects of splendour and display were clearly as important to him and to his patrons as the subject.

Like Gentile Bellini, Carpaccio was inspired by Venice herself. Some of his paintings, like the detail from a scene he *Ill. 47* painted for the cycle in S. Giovanni Evangelista, actually portray the city and show a sensitivity to her unique effects of light which goes far beyond anything in the works of Gentile.

66

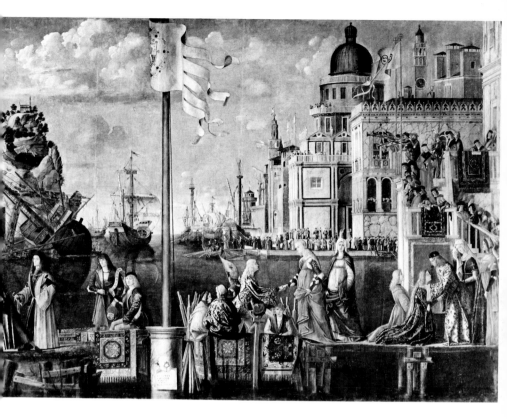

Others, like the scene from the cycle for the Scuola di S. Ursula, *Ill. 46* approach the city in a more imaginative way.

Venice is not literally represented in this painting, but the square buildings and irregular rectangular spaces recall her squares and *campos* (the Venetian name for a small square), and the spatial sensations they evoke remind one of the paintings of Canaletto, who, three centuries later, was to tackle this subject-matter in a directly topographical way. What Carpaccio gives us is a fantasy Venice, in which the colour is brighter, the marbling richer, the architecture more bizarre, and the populace more splendidly costumed and better brought up than in the city herself. A Venice, too, in which, by the formal perfection of the composition, all activity is poised, as in a dream, in magic stillness.

Carpaccio is indeed essentially a classical artist. His paintings show that spatial control and very precise sense of interval which we find in other intuitively classical painters, such as Vermeer and Canaletto. For all the bustling action, the final effect is static: everything has its place in an ordered and timeless world.

In the general context of Venetian art as it develops into the sixteenth century, Carpaccio, who did not die until the mid twenties, is a figure by himself, the values of whose painting become more and more isolated. It is amazing to realize that the meditative, still-medieval imagery of his devotional master-

Ill. 48 piece, the *Laying-out of Christ*, in Berlin – a theme incidentally Byzantine in origin – could still be fresh and alive for him in the first decade of the Cinquecento when Giorgione and Titian were painting the foundation works of the Venetian High Renaissance. Yet the profusion of descriptive detail is unified by a mood of compelling sadness, which is perhaps a personal equivalent for the new kind of poetic painting of mood which the young Giorgione was, at the same time, creating in Venice. Despite its imagery it is impossible to imagine the picture, one of the most individual and inexplicable masterpieces in European painting, being conceived in the Quattrocento.

The other major painter of the Late Quattrocento is Alvise Vivarini. He too owed the survival of his fame partly to his activity as a narrative painter, for in 1488 he requested and was granted the right to work on equal terms with the Bellini in the Sala del Maggior Consiglio. All three of the canvases he was allotted there were unfinished at the moment of his death, but the success of his request shows that he was regarded by contemporaries as the artist nearest in standing to the Bellini – partly, perhaps, because of the long-standing prestige of his family workshop, which went back to the days of his father Antonio.

His early works, dating from 1475 to 1480, such as the *Christ carrying the Cross* in SS. Giovanni e Paolo, are variants upon Giovanni Bellini's early poetic manner. In about 1480 he came

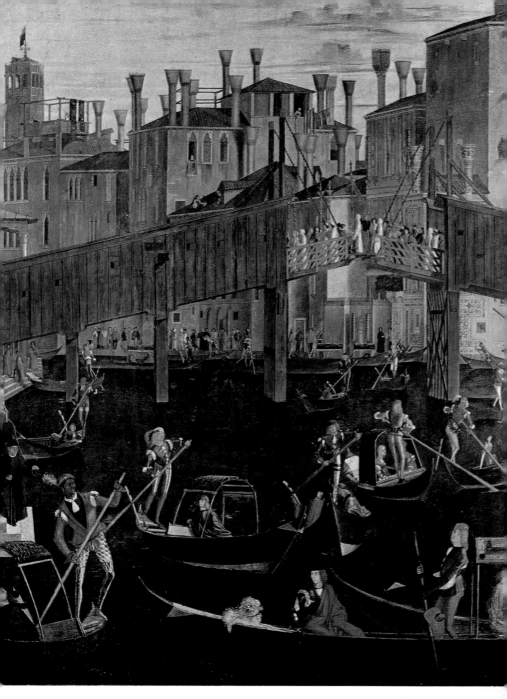

47 VITTORE CARPACCIO *Miracle of the Reliquary of the True Cross* (detail) 1494

under the influence of Antonello, whose particular under-
standing of light he probably grasped more fully than any
Ill. 49 other Venetian painter. His *Madonna and Child* of 1483 at
Barletta has a cone-like grandeur and simplicity of form and
an absolute consistency of modelling by light, which shows a
complete acceptance of Antonello's principles.

In his late style, which develops about 1497, Alvise antici-
pates some aspects of the Venetian High Renaissance. His
Ill. 50 *Resurrection* in S. Giovanni in Bragora, dated to 1498, is still
very dynamic and dramatic, although surface damage and the
fact that the panel has been cut, mar the effect. The narrative,
instead of being diffused throughout the landscape as is usually
the case in Quattrocento Resurrections, is concentrated on
the three figures, who come right up to the foreground of the

48 VITTORE CARPACCIO *Laying-out of Christ c.* 1519

49 ALVISE VIVARINI *Madonna and Child Enthroned* 1483
50 ALVISE VIVARINI *The Resurrection* 1494–8

picture. The scene is dominated by the figure of Christ, whose vigorous turning movement controls the composition. Narrative thus becomes drama, and in this concentration on a single monumental figure, and his control of the composition by movement, Alvise anticipates the style of the sixteenth century. The vigour of movement in his late paintings seems indeed to have interested both Giorgione and Titian, and, in so far as it provided an alternative to the static composition of the late Bellini, played its part in the development of Venetian High Renaissance art.

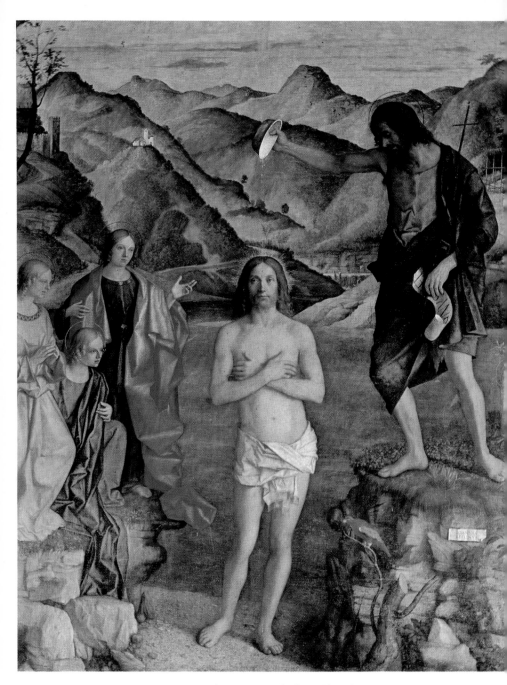

51 GIOVANNI BELLINI *The Baptism of Christ* (detail) 1501

The Venetian High Renaissance

The art of the Venetian High Renaissance, which developed parallel to that of Rome, was the work of three masters: Giorgione, Titian, and Sebastiano del Piombo. All three were, according to Vasari, trained in the studio of Giovanni Bellini and, since they all seem to have been born in the late seventies or early eighties, they must have been in his studio around 1500. By that year Bellini's late style was already formed, and, revolutionary as it was, must have had a profound influence on these young artists. He himself, although already about seventy, had sixteen years to live, and during this time he remained astonishingly open creatively, so that he in his turn was influenced by the younger generation. His late works are especially moving. They show that in art it is often the very old who are the greatest revolutionaries.

Bellini's late style was already fully formed by 1501–2 when he painted the great *Baptism* for S. Corona in Vicenza. This is *Ills. 51–2* a full-scale altarpiece, nearly fourteen feet high, which still stands on the altar for which it was painted. In it the Venetian feeling for colour is related in a new way to visual experience and the traditional concerns of Venetian art are reformulated in an up-to-date form for a new generation.

Bellini, abandoning line as artificial, now begins to visualize the world in patches of pure colour. The shapes in the *Baptism* form themselves out of areas of contrasted and related colours and the artist finds marvellous analogies of colour between the forms, so that the whole painting is woven into what has been described as a carpet or tapestry of colour.

To develop this style Bellini leaves behind linear perspective. It distances things, showing them as we know them to be, leading away in an orderly progression one behind another

73

into depth. But we do not see like that. Our eye jumps the foreground and perceives distant things directly; and it is this central fact of vision that is at the core of Bellini's late painting. He does not deny space, but he makes it more directly a function of vision, so that forms in depth and forms on the surface come together on the plane of the picture, as they do on the retina, and space is experienced with the richness and ambiguity of perceptual experience itself.

Thus in the *Baptism* the landscape is physically felt. The hills, although in fact so far away, seem near as they often do at evening, and Bellini conveys the dense closeness of the valley which surrounds the figures. In this he gets back to the physical immediacy of spatial experience conveyed in the drawings of his father and his own early works, but does so with a far greater understanding of the visual phenomena involved. By climbing Monte Berico behind Vicenza at evening one can see how, as in Bellini's painting, the distant hills become very flat and near in the evening light and how their dense planes of soft colour seem to build up and press together. The *Baptism* is in a new way a record of something seen, and its structure as a painting derives from visual experience.

At the same time the painting is beautifully ordered within its frame and has the internal harmony of truly classical art. In the terms of Bellini's late style this harmony comes, not only from the internal balance of the composition, but from the fusion and interrelation of colours as a pattern on the surface of the picture, which, without violence to the facts of vision, brings together forms at different positions in space. Space itself becomes dense because it too is treated as colour, and the natural distinction between solids and voids is translated into a higher harmony.

Ill. 54 In the *Virgin and Child with the Baptist and a Female Saint* in the Accademia, the water wedged between the foreground forms of the figures becomes almost vertical, and the soft pinks, yellows, and blues of the distant hills and houses are woven together with the colours of the figures and the sky. The paint

74

52 GIOVANNI BELLINI
The Baptism of Christ
1501

itself becomes a tactile element in the surface pattern, and one can sometimes see the artist's finger-marks where he has fused an edge or blurred a contour.

This style reminds one of Cézanne and in these late works Bellini goes beyond the conscious ends of painting in his own day and touches on what, in some obscure way, we can apprehend as the timeless necessities of the painter's art. For him as for Cézanne painting becomes an act of resolution and possession in which all things are woven together into a new unity on the canvas by the power of the artist's vision and his ability to grasp it in paint. At the same time, because for a painter seeing is a way of living, this vision is an expression of the artist's own *Weltanschauung*, so that the warm, urbane harmony of Bellini's late paintings is the sum of his whole experience; a marvellous affirmation of his faith in life. In the last of his 'Sacre Conversazioni', painted in 1505, all distinctions *Ill. 58* are abolished and the atmosphere becomes as dense as the

75

figures. The forms in the painting are fused together into a warm golden harmony, and, although the content of such a painting cannot be verbally defined, it is difficult not to feel that what we have here is not an orthodox faith in the creation as a reflection of the Creator, but an almost pantheistic intuition of the unity of all things in which matter and spirit become one.

This intuition of unity transcends the individual subjects of Bellini's late paintings and is present also in the pagan subjects, which he had first started to paint in the nineties. Such subjects as the *Feast of the Gods*, which he painted for Alfonso d'Este two years before his death in 1516, are close to the 'poesie' of his young contemporaries Giorgione and Titian, but he gives them his own flavour. Although the subject matter is classical, they are more realistic and less idealized than the romantically sensuous works of the younger generation, and express, through

53 GIOVANNI BELLINI *Young Woman with a Mirror* 1515

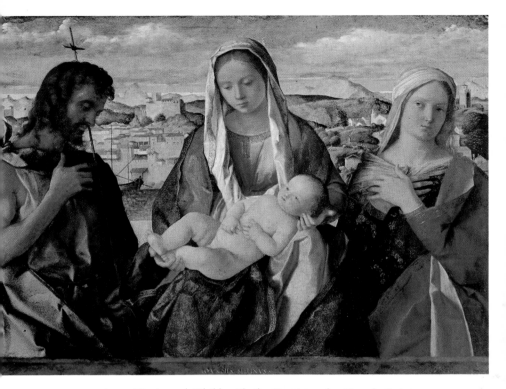

54 GIOVANNI BELLINI *Virgin and Child with the Baptist and a Female Saint*
c. 1504

intimations of Antiquity, a vision of life, which is both contemplative and warmly physical.

In the painting at Vienna dated 1515 of a woman dressing *Ill. 53* her hair, the figure is neither explicitly a Venus nor quite an ordinary mortal. Her body, for all its beauty, is only an element in a total harmony in which the damask of the head-dress, the green of the curtain, the bright colours of carpet and landscape, the soft pink of the drapery, and the pearly flesh-tones of the figure herself are knit together into a unity. Sensuous in colour as scarcely any painting before it, it is yet without any hint of carnality. The ultimate content of the painting is this marvellous perception of oneness, in which by the magic of colour everything relates to everything else and becomes harmonious and whole.

77

Historically, the importance of Bellini's late works can hardly be over-estimated. They bring Venetian painting back to its central concerns: colour, texture, and surface pattern. These things are part of the Venetian tradition, going back to the mosaics and enamels in S. Marco, where each tessera or segment of enamel is at the same time beautiful as a material in itself, part of a total surface pattern, and a fragment of the image for which it stands. Equally, in his rejection of linear perspective and the constructed space of Central Italy, Bellini in his late style is making the same decision as Paolo Veneziano and his contemporaries, when they ignored the style of Giotto in favour of a more directly visual approach to nature. Bellini, through his realization that colour is the main constituent of vision, brings this tradition up to date and hands it on to the painters of the High Renaissance. Turning, as they now did, to Classical sculpture and the Roman High Renaissance for inspiration, the artists of the younger generation could express their new ideals in a language which was entirely Venetian. Over against the sculptural tradition of Rome, they could create a 'painterly', 'colouristic' art, no less of the High Renaissance and no less important for the future development of European painting.

Giorgio da Castelfranco was the eldest of the founder masters of the Venetian High Renaissance. He was born either in 1477 or 1478 – Vasari gives the date differently in his two editions – at Castelfranco, a small walled town in the Veneto some forty miles north of Venice. He died young, probably of the plague, in 1510, and because of his early death, physical beauty, musical talents, and reputed grace of manner he seems a romantic figure; a kind of Cinquecento Keats.

This conception of him is greatly enhanced by his paintings, which evoke a poetic mood, both ambiguous and highly personal. He is the creator of a new genre of painting, the 'poesie': a kind of painting with figures in landscape in which the subject, if it is there at all, is of little importance and the

poetic mood the *raison d'être* of the picture. Although the mood in his own works is essentially subjective and indefinable, a school of 'poesie' painters developed after him, and the generic name 'Giorgionesque' is given to a whole generation of painters who, between 1510 and 1520, followed his example.

A new understanding of shadow is at the heart of Giorgione's painting. This was already noticed by Vasari, who says that he had learned it from Leonardo da Vinci, and since Leonardo was in Venice in 1500, there is probably some influence. The extraordinary subtlety of Giorgione's 'sfumato' – the soft gradation from light to dark – can be seen in a detail of his early *Adoration of the Magi* in the National Gallery, London. *Ill. 55* Through this 'sfumato' he gives a wonderful fullness to the forms and great atmospheric density to the space. Never before, perhaps, had painted forms seemed so rounded, so soft, and so sensuous, and it is this physical intensity which is Giorgione's first contribution to painting. But with him physical things are never simply themselves. They are charged with a subjective content, and the depth of shadow seems a manifestation of a profounder mystery: an intimation of the inner strangeness of personality itself.

Giorgione breaks the balanced order of Quattrocento art to explore through new modes of composition a different level of feeling. In his only surviving altarpiece, the *Castelfranco Madonna*, probably painted in about 1504, he uses all the *Ill. 59* elements of a Quattrocento 'Sacra Conversazione' but rearranges them in a new way, so that they convey a different content; a comparison with Bellini's S. Zaccaria altarpiece, *Ill. 58* which was painted at almost the same time, shows how great the difference is.

In Bellini's painting, the figures are grouped within an apse, the curve of which brings the eye back to the surface. The whole work is internally balanced and self-contained and has that inner harmony which is the chief quality of the best Quattrocento and High Renaissance art. In Giorgione's painting there is no such inner order, and his manner of composition is

79

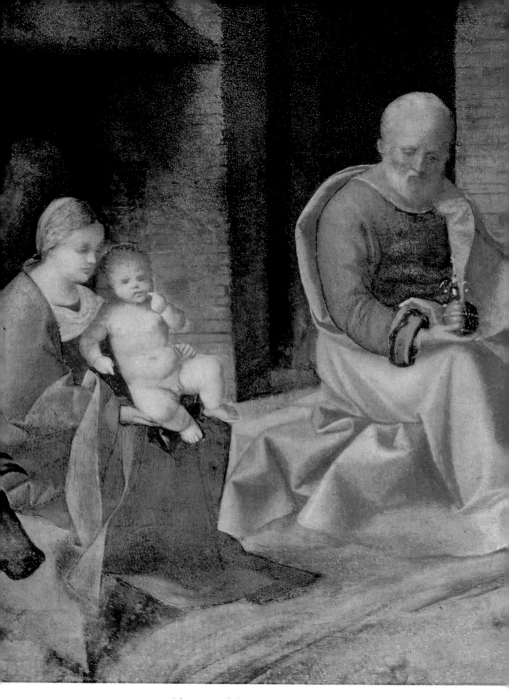

55 GIORGIONE *Adoration of the Magi* (detail). One of a group of small-scale
works now usually accepted as the early works of Giorgione

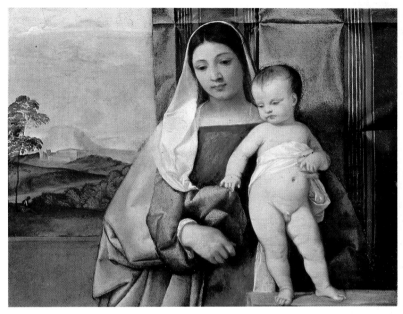

56 TITIAN *Gipsy Madonna*, one of Titian's earliest works

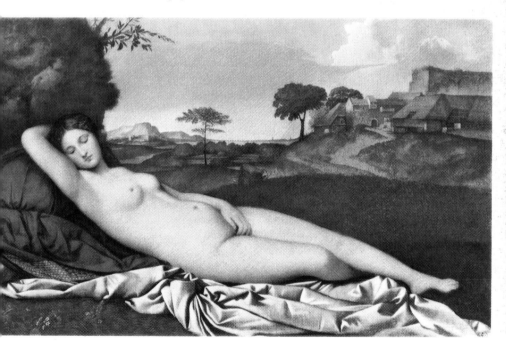

57 GIORGIONE *Venus* 1509–10 A figure of Cupid too badly damaged to be restored is painted out on the right

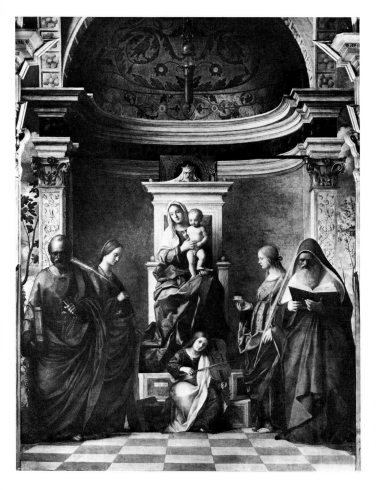

58 GIOVANNI BELLINI
*Virgin and Child
Enthroned with Four
Saints*, 1505, known
as the S. Zaccaria
altarpiece

different from that of even his greatest contemporaries. In the
Castelfranco altarpiece the forms are not brought back to the
surface, but are simply cut at the sides, so that they suggest
the infinity of space extending outside the frame. The space of
the picture ceases to be self-contained, and becomes a part of the
greater whole, while the balance between space and figures is
altered. The figures now seem almost threatened by an environ-
ment which is no longer made to their measure, and it is for this
reason that the picture, for all its sweet peacefulness, has a
strange loneliness which is new to Renaissance art.

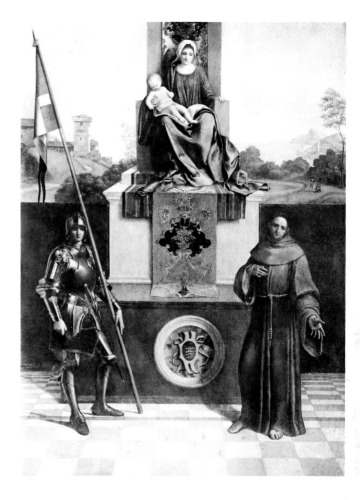

59 GIORGIONE *Madonna and Child with St Liberale and St Francis*, known as the Castelfranco altarpiece *c.* 1504

By the same token the Madonna is strangely isolated from the attendant Saints. Giorgione uses a perspective so artificially steep that it separates the lower part of the picture from the upper. The Madonna is thus cut off from human contact, and by a poetic analogy which is part of the language of painting, she seems one with the landscape: her slightly troubled, inward expression all of a piece with the still atmosphere, the drooping flag, and the muffled distances of the Venetian plains in which the feet of the mountains are lost in mist.

83

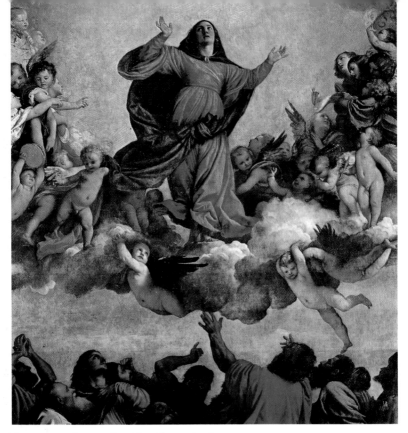

60 TITIAN *Assumption* (detail) 1516–18

61 TITIAN *Twin Venuses* (detail) *c.* 1515

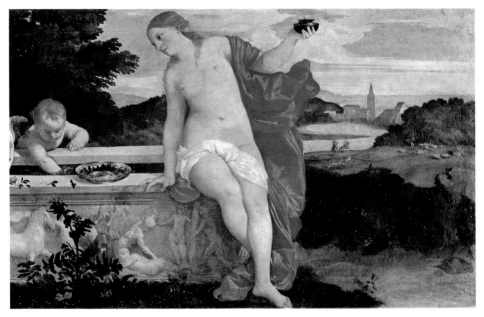

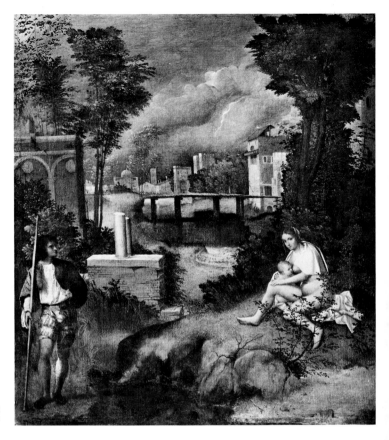

62 GIORGIONE
The Tempest

The outer calm of the scene masks a tension, which arises not from the nature of the subject but from the way it is put together. From this comes our strange sensation that the painting is not so much the illustration of a theme as the objectivization of an inner event. It is about the mysteries of the psyche rather than the mysteries of theology, and prepares us for the more overt subjectivity of Giorgione's 'poesie'.

The most famous of these is the *Tempest*. Almost certainly *Ill. 62* this painting had no literary subject. It is described by the Venetian connoisseur Michiel, writing in 1530, simply as 'a landscape with a storm and a soldier and a gipsy', and in addition we know from X-rays that under the soldier there is the almost complete figure of a nude woman dabbling her feet in the water.

85

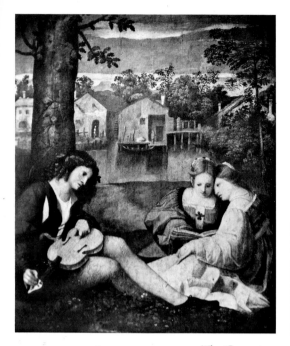

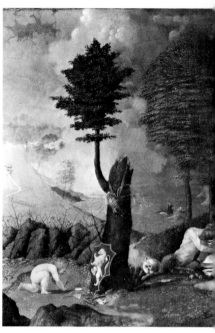

63 PALMA VECCHIO *The Concert* 64 LORENZO LOTTO *Allegory* 1505

So radical an alteration shows that Giorgione changed his mind about the content of the picture as he went along and seems to preclude a set theme. This change in the *Tempest* tells us something important about Giorgione's method of composition and his whole creative process. It suggests that for him, painting was a process of exploration by which he discovered not only his means of expression but what he wanted to say, evolving the content of his painting as he composed it on the canvas. Composition was not so much illustrating a theme as working one out, and, in the case of the *Tempest*, the changes he made are vital to its final meaning: that mysterious inner tension which has made it so famous.

This content can never, of course, be defined, but it certainly depends largely on the division – comparable to the vertical division of the Castelfranco altarpiece – between the two sides, which seem to slope away from one another and are held

65 GIORGIONE *Three Philosophers* c. 1508. The canvas has been cut on the left, so that some of the cave, which was remarked on in the sixteenth century as of especial beauty, is lost

together in a precarious unity only by the bridge. Between them comes the dramatic fierceness of the storm, and it is to this tense relationship between the two sides of the painting that the final arrangement of the figures relates. By replacing the original nude with a clothed male figure Giorgione adds a psychological tension which exactly complements the physical tensions of the landscape and fuses together human and natural forces into a larger whole. The uniqueness of this fusion can be seen by comparison with an almost contemporary 'poesie' by Lorenzo Lotto, painted in 1505, which for all the romantic *Ill. 64* drama of storm and tree has none of the inner tenseness of the *Tempest*. And in Palma Vecchio's *Concert* the theme of figures *Ill. 63* in landscape is reduced, albeit charmingly enough, to the level of an elegant picnic.

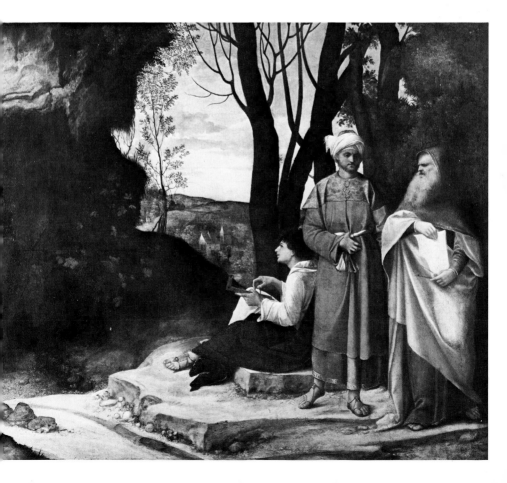

The new interrelation between human beings and nature is developed in what is probably a slightly later work: the *Three* *Ill. 65* *Philosophers* in Vienna. In Bellini's *Transfiguration* and even in the *Tempest* the figures are set back in the landscape and distanced from the spectator. Here, large landscape forms come right up to the foreground and enclose the figures, so that we experience with a new immediacy all the physical sensations of the landscape: the enclosing glade, the mysterious depths of the cavernous rock, and the sudden vista into space between the shady trees.

The title by which the picture is generally known is given by Michiel, but its subject has had many interpretations, of which the most probable is that it represents the Three Kings, who are often described as sages or philosophers, awaiting the coming of the Star of Bethlehem. But in any case, whatever the specific subject, the painting's content cannot be confined to it alone. As subject-matter, the cave, for example, very probably represents the 'Lucula Noctis', the birth cave, and is associated with Christ. But this is only one of the many meanings which the cave has had in the symbolism of mankind, and as a painter concerned, by the nature of his art, not with ideas but with things, Giorgione goes to the physical source of all these symbols, re-creating in his painting of the cave a living evocation of those compelling and elusive depths from the experience of which all this symbolism sprang. His art reaches the core of man's physical and spiritual involvement with his environment and in this lies its deeper meaning and its perennial power.

Paintings like the *Tempest* and the *Three Philosophers* are, of course, original not only in theme but in type. They are cabinet pictures with no obvious didactic purpose and seem to have been painted for a new kind of young patrician patron, who enjoyed paintings for their own sake. A new class of collector was developing at the end of the fifteenth and the beginning of the sixteenth century, not only in Venice but throughout the cultivated society of the Italian courts and

cities, and Isabella d'Este, for example, sought eagerly for works by Giorgione.

As a result of their private character, none of Giorgione's early works is authenticated by documents. There is only one dated painting, the Vienna *Laura* of 1506, and even that is only *Ill. 88* authenticated by an inscription. The *Three Philosophers* is, however, usually thought to be a work of Giorgione's maturity, painted a little before the frescoes for the Fondaco dei Tedeschi which he was commissioned to execute in 1508, only two years before his death. These frescoes, on which Titian collaborated, were a public commission for the outside of an important civic building, and they seem to have showed him developing a less purely personal style, in which he expressed in his own way the ideals of the nascent High Renaissance.

The subjects of the frescoes were mostly nude figures, but since they were all destroyed, it is only from engravings and one stained fragment that we can get some idea of their geometric purity of form. In them Giorgione seems to have revived the formal perfection of Greek sculpture in the Polycleitan Age, arriving by intuition rather than example at the principles governing the purest Classical conception of the nude. At the same time he re-created this ideal with a sensuous warmth and intensity of colour which are entirely Venetian.

This is the style which we see in the Dresden *Venus*, whose *Ill. 57* pose derives from an Antique *Venus Pudica*, but whose form has the softness of life. Here, by a poetic invention of great simplicity, Giorgione associates the purity of the Classical nude with the beneficent beauty of a calm landscape, creating an image which was to be fruitful in European painting for four centuries.

The landscape of the Dresden *Venus* was, according to Michiel, painted by Titian and at this stage, immediately before Giorgione's death, their styles come together, so that the attribution of several masterpieces of Giorgionesque art belonging to this period, most notably the *Fête Champêtre* in the Louvre, is often disputed between them. Probably a number

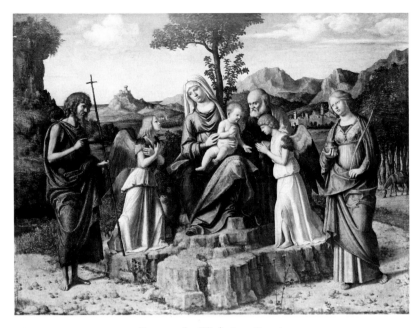

66 GIANBATTISTA CIMA *Rest on the Flight into Egypt*

of paintings were left unfinished in the studio at Giorgione's untimely death and were completed by Titian, or Sebastiano, or both.

In the hands of lesser followers Giorgione's style loses its subtlety and resolves itself mainly into a mood of gracious pastoral calm, conveyed through fuzzy atmosphere and soft planes of singing colour. As an example, Cima's *Flight into Egypt* at Lisbon shows how his poetic mood can be imposed without difficulty on a conception still essentially of the Quattrocento. Cima (*c.* 1459–*c.* 1517), who was born in Conegliano, arrived in Venice in about 1490, and practised for the next three decades a style of easy three-dimensional naturalism which, although it has none of the pictorial or visual subtleties of Giovanni Bellini's painting, enjoyed great popularity. It is easy to dismiss his paintings as pedestrian and repetitious, but he responded individually to the character of his native landscape and had a real feeling for light.

Ill. 66

Vicenzo Catena (active 1495–1531) is the artist who comes nearest to making something personal out of the Giorgionesque, and since, in the inscription on the back of the *Laura*, he is described as a colleague of Giorgione's, it is possible that he had some special professional connection with that artist. Catena's early works are crude variants after Bellini, but he learnt quickly and evolved an individual style of telling simplicity. His figures have simplified, rather balloon-like forms, and are usually placed in a frieze against a calm landscape, which is built from soft planes of warm colour. *Ill. 67*

Close to Catena is Marco Basaiti (active 1496–1530) who took up the late manner of Giovanni Bellini without really understanding it. His most striking works are two altarpieces (the *Calling of the Sons of Zebedee* and the *Agony in the Garden* of 1510 and 1516) in the Accademia, in which, following Bellini's Vicenza *Baptism*, landscape has a large place. They have a certain superficial charm of mood, but close inspection reveals a vacuity of sentiment and lack of substance in the forms.

67 VICENZO CATENA *Vision of St Christina* (detail) 1520–1

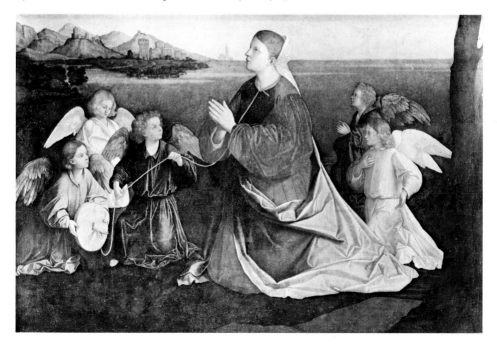

Of the three founder figures of the Venetian High Renaissance, Sebastiano Veneziano (born *c.* 1485), later called del Piombo (from an office of profit which from 1531 he held from the Papacy), was acknowledged, even by contemporaries, to be the least gifted. Nor is he as important to Venetian art as he might have been, for in 1511 he left Venice for Rome and remained there for the rest of his life. His earliest Venetian work, four paintings of full-length saints on the organ shutters of the Church of S. Bartolommeo, are very Giorgionesque. In *Ill. 68* the *St Louis of Toulouse*, for example, the soft volume of the head is wonderfully absorbed into the ambient atmosphere of the niche in which he stands, and as the figure dates from the same time as the Fondaco frescoes it is clear that Sebastiano developed alongside Giorgione in the creation of a Venetian *Ill. 69* High Renaissance style. A year or two later, in the figures on the outside of the shutters and in the high altar for the Church

70 SEBASTIANO DEL
PIOMBO *Virgin mourning
the Dead Christ* c. 1517

of S. Giovanni Crisostomo, Sebastiano developed this style towards a new fullness of form and breadth of movement, which seems to be due to the influence both of Antiquity and of the Florentine Fra Bartolommeo, who was in Venice in 1508. At this stage in his career Sebastiano already liked to relate his figures to architecture, and was aiming for a monumental effect.

After his arrival in Rome, he became attached to the circle of Michelangelo and painted his *Raising of Lazarus* (now in the National Gallery, London) with the aid of drawings by Michelangelo, in competition with the *Transfiguration* of Raphael. His attempts to fuse a Venetian sense of colour and light with a Roman solidity of form result in an oddly artificial style, which is powerfully rhetorical but never quite convincing. The parts, often individually well conceived, do not add together, because they are bound by no governing principle; neither by the constructional sense of the Roman school nor by the visual sense of the Venetian. His *Virgin mourning the Dead Christ* at Viterbo, also based on a design by Michelangelo, *Ill. 70*

93

68 SEBASTIANO DEL PIOMBO *St Louis of Toulouse* 1507–9 (detail)
69 SEBASTIANO DEL PIOMBO *S. Giovanni Crisostomo and Six Saints* 1508–10

is worth reproducing in a history of Venetian art not because it plays any part in the development of the school, but because it shows how far away from its traditions Sebastiano had travelled. Here light and colour do not build form, they are simply applied to forms already existent, and in this lies the victory of the Roman over the Venetian principle in Sebastiano's painting.

The early death of Giorgione and the departure of Sebastiano left the field to Titian, and from Bellini's death in 1516 until his own in 1576 he was undisputedly the leading painter in Venice. During this period he developed all the special qualities of Venetian painting on both an intimate and a monumental scale, and through his personal fame spread its ideals throughout Italy and northern Europe. By the time of his death, the prestige of Venetian art was almost equal to that of Rome, and his supporters could argue that, although Michelangelo was the greatest sculptor who had ever lived, Titian was the greatest painter.

There is doubt about Titian's birth-date. In later life he exaggerated his age to gain the sympathy of his patrons, so that his birth-date has sometimes been placed as early as 1473. But in fact his earliest surviving works belong to the period 1506–12 and, unless he developed late, it is likely that at this time he was still a young man: at most in his early twenties.

Ill. 56 The *Gipsy Madonna* in Vienna shows the close dependence of his early style on Bellini – it relates to the Bellini *Madonna and Child* at Detroit dated 1509 – but the oval of the face has a new fullness, and the plump lips and chestnut hair establish the new, fleshy type of beauty which was to become known as 'Titianesque'. The ample forms are spread broadly across the plane, and the warm and ruddy fleshtones, in which strokes of pure red show in the modelling of the face, make a rich harmony with the rust and green of the dress.

Ill. 71 This new fullness of colour, and a new freedom and juiciness in the actual painting, appear also in the *Noli Me Tangere*

94

in the National Gallery, London. Titian makes his effect through the simple juxtaposition of strong colours, developing Bellini's vision of the world in terms of colour on a broader and more opulent scale to become the basis of a new, monumental art. He is now exploiting the potentialities of the oil medium to the full. The X-ray shows how he actually evolved *Ill. 72* the composition on the surface of the canvas, completely reversing his original arrangement of the scene to achieve the flowing rhythms which now unite figures and landscape. This is the equivalent, carried out on the canvas itself, of that testing and moulding of a composition through preliminary drawings and studies which Leonardo developed in Florence. Both he and Titian were aiming at a new kind of highly integrated composition, in which form and content evolve together to create compositions which are both harmonious and highly dramatic: the formal harmony arising directly out of the dramatic action.

71, 72 TITIAN *Noli Me Tangere* *c.* 1511–15, and X-ray, showing Christ turned to the left with the landscape massed behind Him

From this painterly and rhythmic style, with its sweeping forms and strong rhythms, Titian created in the years following 1516 the great masterpieces of Venetian High Renaissance art; works which challenge the monumental masterpieces of the Roman High Renaissance on their own ground. His works were painted in oil on canvas rather than in fresco on walls, but they have the same breadth, majesty, and internal harmony as the great works of the Roman High Renaissance. They are the Venetian equivalents of the Sistine ceiling of Michelangelo and the Stanze of Raphael.

Ills. 1, 60, 73 The first of these works was the *Assumption of the Virgin* for the Church of S. Maria Gloriosa dei Frari, painted between 1516 and 1518. We have already discussed in the Introduction the painterly technique of this work, the visual character to Titian's approach to form, and the part played by colour in building up the sonorous harmony of its composition. Its formal arrangement is equally revealing. The vigour of movement in the spiralling Virgin must not distract us from the fact that, in the manner of High Renaissance composition, the different elements of the painting are clearly distinguished from each other, and even related to the proportions of the monumental carved wooden frame which, with its great columns, was commissioned along with the painting. Thus the glorious arc of light against which the Virgin is set – an equivalent incidentally of the gold mosaic semi-domes of Byzantine churches – completes the circle begun by the arch of the frame, and the tops of the plinths which support the giant columns (just visible on the left of the illustration) are level with the heads of the Apostles, clearly dividing up the composition. Across this separation, interlocking gestures and rhythms link the different parts of the subject into an organic and dramatic whole.

The *Assumption* is vast in scale, and the boldness of its central colour harmony, the rose of the Virgin's cloak, the blue of her dress, and the yellow of the sky, is designed to be seen from a distance down the length of the church. The brush-work

73 TITIAN Detail of the
Assumption (*Ill. 1*)
1516–18

too is large and bold and the forms, like the head of the Virgin, *Ill. 73*
are built up with the greatest economy from the minimum of
strokes. With extraordinary sureness of eye, Titian observes
the data of perceptual experience from which our knowledge
of form is built, and finds for it a clear equivalent in paint.
His understanding of the potentialities of his medium is now so
great that he grades the brush-work, which is dense in the
centre but looser and more open at the edges, so that the forms of
the child angels become less and less substantial, until at the
very edge they emerge only as a few strokes of yellow on
yellow and seem actually to be painted in light.

The *Assumption* was such a revolutionary work that the
Friars at first refused to accept it, but once accepted it achieved
immediate fame and established Titian's reputation once and
for all. Almost immediately he was commissioned to paint on
the left-hand side of the same church the *Votive Picture of the*

74 Engraving after TITIAN *Death of St Peter Martyr.* Until its destruction this was one of the most admired and influential of Titian's works

Ill. 75 *Pesaro Family*; a commission completed only in 1526. The painting has a secular opulence which sets the tone of Venetian religious painting for much of the rest of the century. The pride and splendour of a Venetian patrician family are brought into the service of the Madonna, but the emphasis is as much on them as on her. The balanced and calm harmony of the Quattrocento 'Sacra Conversazione' is here replaced by a vigorous, asymmetrical composition in which the family assertively present themselves to the Madonna and are enthusiastically received by her. Again the colour harmonies are as vigorous as the forms, and Titian gives the painting an internal balance, against the diagonal movement of the figures, by building a central triangle of strong colour with its apex in the blue and yellow of St Peter's robes.

The last of the three major works for Venetian churches, with which Titian established his monumental style, was the

Ill. 74 *Death of St Peter Martyr* for the Church of SS. Giovanni e

98

75 TITIAN *Votive Picture of the Pesaro Family* 1519–26

Paolo, finished in 1530 and burned in a fire in 1867. It developed the pathetic and dramatic relationship of figures to landscape, already seen in the *Noli Me Tangere*, with a vigour and a passion which made it, until its destruction, one of the most famous of all works of European art. The conception of the whole is in the Venetian tradition – indeed we may compare it with Lorenzo Veneziano's tiny *Conversion of St Paul* of two centuries earlier – but the violent movements and gestures of the figures show an understanding of classical dramatic pathos which reveals Titian's knowledge of the *Laocoön* discovered in Rome in 1506. In all these works Titian reconceived what he learned from the art of Antiquity and Central Italy in his own pictorial language to create a style, both painterly and classical, which is the basis for the future development of the Venetian school.

During the same period Titian was also creating, out of the example of Giorgione and the late Bellini, a new type of mythological painting. The *Twin Venuses* of about 1515 in the Borghese Gallery, Rome, represent human and heavenly love. They are still partially Giorgionesque, but the ample

Ill. 61

nude already fulfils Titian's own ideal of form, and the broad, singing planes of colour apply Bellini's ideals with the fullness and freedom of a new age. Under the patronage of Alfonso d'Este, and following on from Bellini, who had already painted the *Feast of the Gods* for the same room, Titian now painted a series of dramatic mythological paintings which, although he himself later described them as 'poesie', are really something

Ill. 76

quite new. Learned in conception – the *Bacchanal* is based on a description in the *Imagines* of Philostratus of an imaginary Classical painting – they are most original for their frank and earthy paganism and the physical reality which they give to the world of Classical legend. The *Bacchanal* is the first orgy in Venetian art and, with its companions, the *Triumph of Venus* in the Prado and the *Bacchus and Ariadne* in the National Gallery, London, applies to Classical subjects the dramatic values and narrative vigour which Titian had evolved in religious painting. The followers of Raphael were doing some-

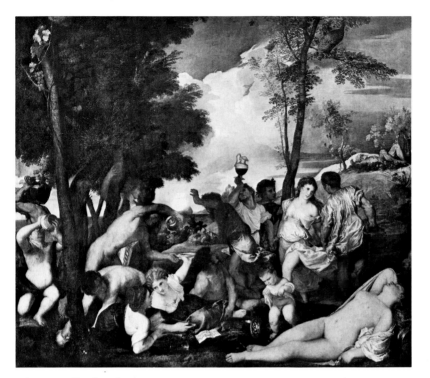

76 TITIAN *Bacchanal c. 1518*

thing similar in Rome, but, in their less sensual art, the Classical world seems more idealized and remote, and it is not difficult to see why Titian's paintings appealed so strongly to a patron of Alfonso d'Este's sensual tastes. It is this carnal confidence and vigour which distinguishes Venetian mythological painting from that of Rome.

The sensuous, not to say sensual, aspects of Venetian art at this period are very apparent in the work of Palma Vecchio (1480–1528). He follows Titian into the High Renaissance, fully understanding the formal values of the monumental art of Central Italy – his paintings often contain quotations from Michelangelo – but adapting them to his own, more sensuous, aims. The *Adoration of the Shepherds* in the Louvre shows him *Ill. 77* massing a monumental composition with considerable nobility but without loss of pastoral intimacy, and his colours, especially

the greens and oranges, have a sharpness and a stringency which contrast with Titian's richer harmonies. Palma had a personal ideal of fair-haired and opulent female beauty, which can be seen not only in his subject paintings but also in a number of portraits of courtesans, which are indeed not so much portraits as images of erotic fancy. As such they belong to that typically Venetian genre, the 'fancy portrait', which will be discussed in the next chapter.

Ill. 92

As a mythological painter Palma is often frankly frivolous. The delicious *Diana and Callisto* in Vienna is a kind of pastoral Folies-Bergère in which the landscape is nearly as artificial as the figures. In some ways, indeed, the spirit of Palma's paintings anticipates the eighteenth century, and it would be interesting to know how his art would have withstood the pressures of the latter part of his own century had he not died in 1528.

Ill. 78

Palma has one significant follower, Bonifazio Veronese (1487–1553), who does not seem to have reached Venice until the year of his mentor's death, but who certainly modelled his

77 PALMA VECCHIO *Adoration of the Shepherds, with a Female Donor*

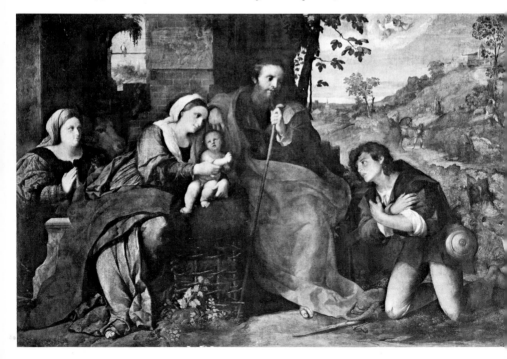

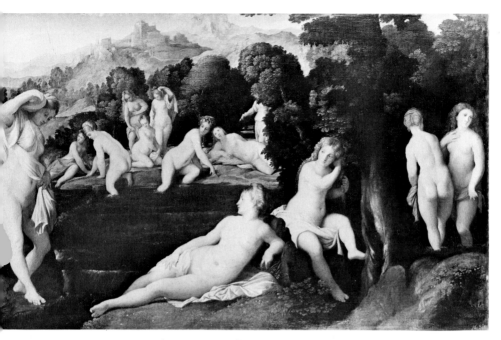

78 PALMA VECCHIO *Diana discovering Callisto.* Compare Palma's relaxed treatment with Titian's dramatic version of the subject (*Ill. 112*), painted some twenty-five years later

style on his. Bonifazio was immensely productive with many followers of his own, and his pallid variants on Palma's pastoral type of religious subject, usually 'Sacre Conversazioni' with figures seated in a landscape, continue until late in the century.

Titian and Palma Vecchio were the leading masters in metropolitan Venice in the second and third decades of the sixteenth century, but two other painters, Lorenzo Lotto and, to a lesser extent, Pordenone, have a major place in Venetian painting, even though they worked mainly in the provinces and in styles which diverged from the mainstream of Venetian art. Both are original and highly eccentric, and Lotto, the more prolific and long-lived master – he was born about 1480 and died about 1556 – especially so. His art is very difficult to place in an historical context, much less define, and even Berenson, after two books and a lifetime of thought, failed to penetrate the mysteries of his style.

79 LORENZO LOTTO *Lucy at the Tomb of St Agatha* 1532

Lotto's beginnings were probably with Bellini, but by 1505 he already showed astonishing originality. Such small scenes as the allegorical cover for his portrait of Bishop Bernardo dei Rossi are comparable in their scale and strangeness of mood to the 'poesie' of Giorgione and may even anticipate them in date. Lotto did not remain in Venice, but moved around Italy, painting first in the Marches and then in and around Bergamo. In 1554 he became a religious in the Holy House of Loreto.

Ill. 80 His three great altarpieces for churches in Bergamo, which were painted between 1516 and 1521, in the same periods as Titian's *Assumption* and Pesaro altar, are High Renaissance compositions, but closer, in their symmetrical arrangement, to Florentine painters like Fra Bartolommeo and Albertinelli than to Titian himself. Yet for all the balance of their compositions, they remain restless in detail, and a passion for bright local colour – the strong yellow for example in the St Catherine on the left of the S. Spirito altar – and smooth hard surfaces prevents Lotto from achieving, or even aiming at, the painterly unity of his contemporaries. This failure to integrate perhaps reflects, at the deepest level, the tensions of a neurotic personality, and what little we know of his personal life suggests that he was not a happy man.

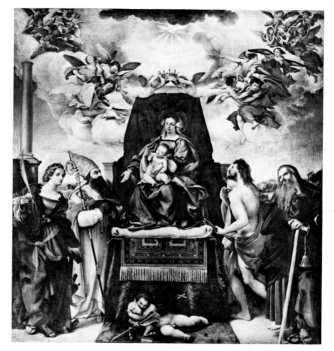

80 LORENZO LOTTO *Virgin and Child enthroned with Saints and Angels* 1521

81 LORENZO LOTTO *Christ taking leave of His Mother* 1521

Lotto never accepted the material and secular values of painting in his native city and the *Christ taking leave of His*
Ill. 81 *Mother* at Berlin, also of 1521, shows how he used ambiguities of space and scale to heighten the religious and visionary effects of his paintings. At the same time he was capable of great intensity of observation, and his works often include passages of detail. Such a passage is the landscape which he painted for the altar of St Nicholas of Bari in the Carmine in 1529, which also shows the development of his style towards a softer handling. By the thirties he was capable of a vision as atmo-
Ill. 79 spheric as that of the predella scene from the Life of St Lucy now in the Pinacotea at Jesi. The scenes of which this is one show some influence from realistic strains in Florentine art of the early sixteenth century, but their sense of scale, their realism, the relationship of the tiny figures to the simple architecture, and above all their smoky, atmospheric spaces have no parallel before Goya. Lotto is indeed an artist of bewildering changes of mood and style, so free from convention that he could on occasion achieve a vision well beyond that of his own age.

Pordenone is a more thwarted figure. Born in Pordenone, probably in 1483/4, he died in 1539. According to Vasari he set out deliberately to challenge Titian, and his searches after a grand manner remind one slightly of the unhappy Benjamin
Ill. 82 Haydon. His *Madonna of Mercy* of 1516, still in Pordenone, is, with its tiny figures of donors kneeling round the Madonna, provincial in conception, but the brooding mood (conveyed by dark indigo tones out of which a few bright colours emerge) is both personal and in tune with the work of his Venetian contemporaries. The vigorous plastic movement of St Christopher in this painting is also typical of Pordenone's art: exceptionally for a Venetian artist, he worked in fresco as much as in oil, and painted fresco cycles in Cremona and Piacanza. In Emila he absorbed a strongly plastic, illusionistic style which he brought to Venice, decorating the façades of a number of buildings with monumental scenes and figures, which have

82 GIOVANNI ANTONIO PORDENONE *Madonna of Mercy between Sts Christopher and Joseph* 1516

83 PORDONONE *Assumption of the Virgin*, a pair of organ shutters designed in dramatic foreshortening to be seen at a considerable height

almost all disappeared. He also introduced illusionistic ceiling painting to the Veneto (for example in the vault of the Capella Malchiostra of the Duomo at Treviso), and his feeling for vigorous foreshortening and dramatic spatial effects reflect this striving after the monumental. It can be seen in his *Assump-* *Ill. 83*
tion at Splimbergo, in which the enormous figure of the Virgin swirls upwards through the blue mists of Pordenone's native Friuli, accompanied by the gestures of the violently plastic figures of the Apostles who are silhouetted against the sky. The Central Italian and Venetian ideals of form and space are here combined, but Pordenone seems to be trying for too much, too hard, and for all its excitement the *Assumption*, like so much of his painting, is an inflated affair.

84 ANTONELLO DA MESSINA *Portrait of Young Man c.* 1475

The Venetian portrait

The development of the portrait as an independent form occurs simultaneously in northern and southern Europe in the middle of the fifteenth century. It is indicative of that new interest in man's humanity as something worth recording for itself, which is one of the most characteristic phenomena of the Renaissance; and Venetian Renaissance portraiture is an important part of the general European phenomenon because the direct concern with individual facts, which we have seen to be typical of Venetian art, is an especially good starting-point for portraiture.

By the middle of the century the profile form of portrait head which, partly under the influence of Antique coins, had been standard with International Gothic artists, was already out of date. Although it provided a satisfactory record of the sitter's appearance, it was too schematic for Renaissance taste, presenting a chart of the sitter's most characteristic features rather than a living image of his person. Antonello and Bellini supersede it with a type of portrait in which a new physical realism is given to the sitter. The figure, seen bust-length and often behind a parapet, is turned in three-quarter view to the plane of the picture, so that space is displaced and the volumes of the figure are given the maximum solidity.

This kind of portrait is Flemish in origin. It was invented by Jan van Eyck, whose work, either in originals or copies, Antonello must have seen in Naples before he visited Venice in 1474. The Eyckian type was followed very precisely by Antonello. The painting opposite, which was painted in Venice and is now in the National Gallery, London, shows it fully developed. In order to give movement to the figure Antonello has turned the head less acutely from the plane than the body, and the

Ill. 84

109

eyes of the sitter are turned even further back, to look directly at the spectator. By this means an extraordinary effect of immediate contact, as between man and man, is created, and the sitter clearly situated, in time and space. We have a direct relationship with someone who lives in the same world as ourselves.

All Antonello's Venetian portraits are of this type, but Giovanni Bellini, although he was working in a similar direction to Antonello even before the latter's arrival, rarely adopted the 'Flemish' manner in this fully-developed form. The psychological intention of his portraits, although partially realistic, is less straightforward. His sitters usually look straight ahead and, sometimes set against a background of sky and clouds, seem to be conceived as much *sub specie aeternitatis* as in the present *Ill. 85* world of time and space. In his *Doge Loredano* in the National Gallery, London, datable to about 1501, there is no doubt of the truth and reality of the likeness: the figure is made of flesh and blood, and, through the soft brush-work of Bellini's late manner, the skin seems porous to the warm light. Yet the symmetry of the arrangement and the fixity of the gaze give the figure a formality, which makes it as well an enduring image of Doge's authority. This combination of the typical with the individual depends here, of course, partly on the special status of the sitter, but it is also a characteristic of Renaissance portraiture as a whole and of Venetian Renaissance portraiture especially.

By 1500 portraiture, in both Central Italy and Germany, was developing through the work of Leonardo and Dürer towards a greater realism and authority. The sitter was now generally shown three-quarter length, with his head placed high in the painting, while his folded arms provided a kind of podium, which gave formal support to the upper part of his body. Venetian portraiture moves in this direction in the late 1490s and in the first years of the sixteenth century. We can see the new form developing in Lotto's portrait of Bishop *Ill. 87* Bernardo dei Rossi, dated 1505, in which the sitter's hand appears

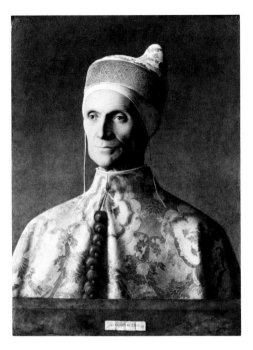

85 GIOVANNI BELLINI *Doge Loredano c.* 1501. The Doge reigned from 1500 to 1521

above the parapet implying the rest of the body below, and a new vitality is given to the whole figure by the turning movement of the body and the intensity of the facial expression.

A comparable development occurs in the portraiture of Giorgione. In one sense he occupies a key place in the history of the Venetian portrait, since, probably partly under the influence of Leonardo, he evoked a sense of the inner life in his sitters which had hardly been realized before. But his contribution is also very personal. He seems to have seen his model through a poetic veil, making one feel that the portrait is as much about his own elusive, inner world as it is about the sitter.

The *Laura* in Vienna, although extraordinarily sensuous – *Ill. 88* we note the softness of the exposed breast and the texture of fur and hair – is yet remote and cut off from the spectator, and her fixed gaze, the formality of her pose, and the emblematic effect of the twisting laurel branches behind her, make her seem an ideal figure, whose sensuous warmth is obtainable only in the imagination. Although certainly a likeness, the

III

Laura is close in feeling to a group of half-lengths of shepherds and other youthful figures, which are not simply portraits. They constitute a new class of poetic or 'fancy' portraits, which became very popular, creating a taste which lasted until the middle of the century. For Giorgione they clearly had a deep significance. They seem often to be self-portraits, and their *Ill. 86* imagery, such as the severed head in the engraving illustrated, is often strange and disturbing. Of course, the artist is here representing himself as David, and the head is that of the giant Goliath, but the motif occurs so often in Giorgione's work, that we are bound to feel that it has a subconscious source. The images in Giorgione's 'fancy portraits', as in his work as a whole, are of a new kind: the product not so much of traditional iconography as of his inner life.

The first portraits of Titian are still Giorgionesque; that is to say, the mood of generalized inner mystery is as important *Ill. 89* as the individual likeness. The *Portrait of a Man* with an enormous silvered blue sleeve, the so-called 'Ariosto', in the National Gallery, London, is an example of this, although the forcefulness with which the personality of the sitter is projected at the spectator is new. Beside the extraordinary physical

86 Engraving after
GIORGIONE
by Wenzel Hollar:
*Self-Portrait as
David with the head
of Goliath*

87 LORENZO LOTTO *Bishop*
Bernardo dei Rossi 1505

88 GIORGIONE *Laura* 1506

assurance of this figure, Lotto's portrait of Bishop Bernardo
dei Rossi, painted a few years before, looks timid. There, *Ill. 87*
personality and life were conveyed mainly through the in-
tensity of the facial expression; here, they come from a new and
forceful combination of all the forms. The whole body is
turned in violent *contraposto*, and the personality of the sitter
is thrust strongly outward at the spectator. Even the texture
of the great padded sleeve adds to the effect of physical assur-
ance: the confidence with which artist and sitter face the world.

 To some extent this new realism of movement and expres-
sion is due simply to the transference into portraiture of forms
already found in religious and narrative painting. It has been
pointed out that the ardent gaze of such a sitter as the 'Ariosto'
is really that of a saint or donor transferred from a religious
painting and put into a fresh context. What is new, of course,
is the concern with the character for its own sake, and we can

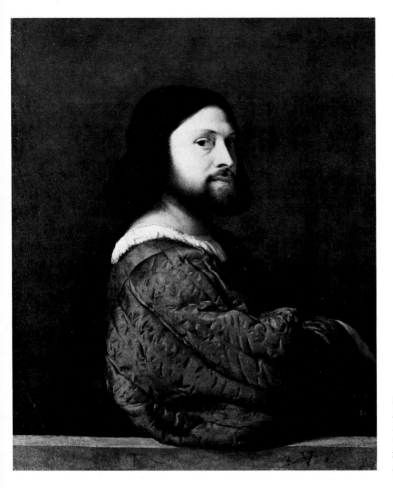

89 TITIAN
*Portrait of a
Man*, for long
wrongly
identified as
Ariosto

Ill. 90

see the same independent interest in psychological values in
another kind of work, half-way between portraiture and
narrative painting, which was created by Giorgione and Titian
at this time. In Titian's *Concert* in the Pitti, three figures
are joined in a situation which is clearly pregnant with human
meaning, although it is given no narrative context. So strong,
however, is the web of psychological tensions woven between
the figures, that romantic nineteenth-century historians felt
bound to find one, and supposed that the scene was the pre-
lude to an assassination. This interpretation is clearly fanciful,

114

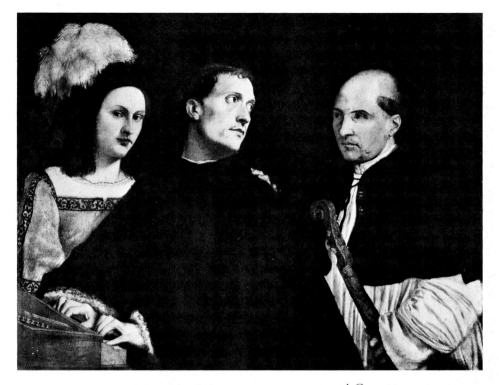

90 TITIAN *A Concert.*
Some authorities
still believe this
painting to be by
Giorgione, but the
attribution to Titian
is more probable

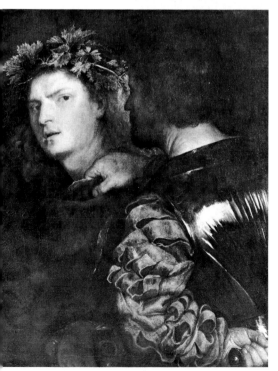

91 PALMA VECCHIO
The Bravo, also
sometimes given to
Giorgione, but
surely by Palma

but an assassination as such is in fact really represented in
Ill. 91 another painting of the same class, the so-called *Bravo*
by Palma Vecchio in Vienna, which shows, in cruder form
the kind of psychological *frisson* these paintings were meant
to give.

The contrast between these two paintings serves to define
the difference between Titian and the only artist who, after the
death of Giorgione, could conceivably be thought his rival as a
portrait painter. Titian's painting creates an elusive, psycho-
logical situation, Palma Vecchio's a factual drama, and similar
distinctions apply to their portraits proper. While Titian's
paintings are poetry, Palma's are prose. In visual terms the
difference comes mostly from the fact that Titian, like Gior-
gione before him, saturates his figures in light and finds in its
elusive beauty an analogy for the mysteries of the human
personality. Palma, by contrast, concentrates on more down-
to-earth physical beauties, strong colours and the rich textures
of brocade and flesh, and his light is less subtle and all-embra-
cing. His most characteristic works are a series of idealized
Ill. 92 portraits of courtesans of a voluptuous carnality, which give
the term 'fancy' in 'fancy portrait' a rather more familiar
application.

Ill. 93 Titian's *Flora* in the Uffizi, although subtler and less carnal
than Palma's courtesans, is essentially the same kind of work.
We do not ask questions about the model, although there must
certainly have been one, because the physical reality of the
figure becomes identified, without loss of sensuous intensity,
with the ideal nymph, and it is in just this essentially Classical
balance between the 'sensuous' and the ideal that the special
character of the Venetian 'fancy portrait' lies.

The *Flora* shows a new phase of Titian's style as a figure
painter. Unlike the so-called portrait of Ariosto, which is very
three-dimensional, it is almost flat, and the structural life of the
painting comes from an interplay of forms on the plane of the
picture. These connect one with another by colour and texture,
and set up tensions across the surface which give the painting

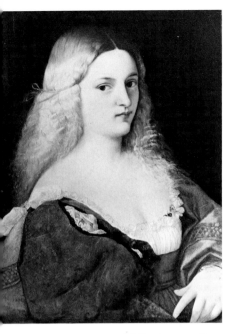

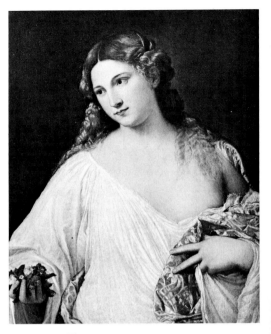

92 PALMA VECCHIO *Violante* 1507–8 93 TITIAN *Flora c.* 1515

its formal life. This was a method which Titian also employed in his straightforward portraits, using a dark all-over tonality, from which a few key forms are strongly picked out by light. An example is the *Man with a Glove* in the Louvre, in which the aesthetic effect depends on the intensity of details and the *Ill. 94* subtlety of the relationships between them. In these paintings Titian showed that an aesthetic order of the highest kind could be created with the simplest means; and their example was to become an inspiration for some of the finest portrait painting of the next century: a direct source for Velazquez and Van Dyck, and an essential element in the art of Rembrandt.

In the early 1530s the course of Titian's portraiture changed. He became fashionable as a court portraitist and, in the succeeding two decades, produced likenesses of most of the leading princes in Northern and Central Italy and many lesser men of eminence. The only place where his portraiture was not

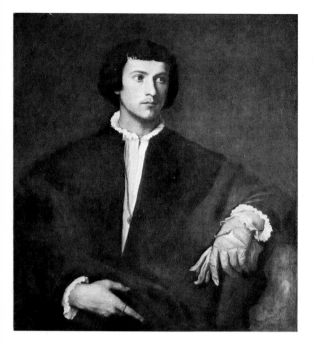

94 TITIAN *Man with a Glove c.* 1523

95 TITIAN *Frederigo Gonzaga, Marquis of Mantua c.* 1523

96 TITIAN *La Bella* 1536–7

appreciated was Florence, which had a highly artificial court portrait style of its own that deliberately eschewed just those elements of sensuous realism which made Titian's portraiture so popular elsewhere.

Titian's patrons bought and commissioned his portraits because they provided exceptionally lively likenesses of themselves, and because they admired them as works of art. By this time they were competing for pictures of all kinds from his hand, and Titian and his studio assistants often produced more than one version of a work in order to satisfy them. The difference between an autograph painting by Titian and a copy was already understood and there was a search for top-quality originals. When, for example, the Duke of Urbino heard that there was an exceptionally fine painting of a lady in blue on Titian's easel (almost certainly *La Bella*, now in the Uffizi, which came from Urbino) he immediately sent his agent to try to acquire it.

Ill. 96

118

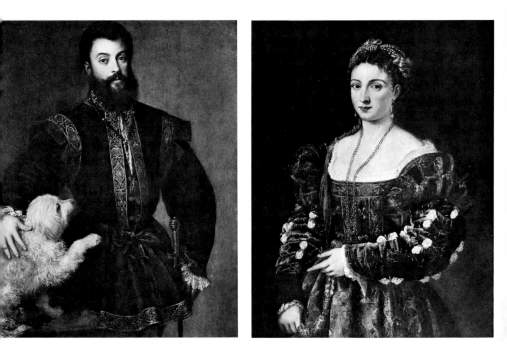

The three-quarter length of *La Bella*, with its richness of
detail and beauty of colour and texture, is typical of the style
which Titian evolved for court portraiture: a style designed
for display and quite different from the severe manner in which
he tended to portray his own countrymen. In his portrait of the
Marquis of Mantua, now in the Prado, the sitter is shown *Ill. 95*
three-quarters length, magnificently dressed in red stockings
and a blue velvet doublet fretted with gold. His figure, set
against a luminous, exquisitely modulated grey background,
is enveloped by light, and through this interplay of light and
colour, Titian achieves a physical splendour appropriate to
the sitter's status and aesthetically of the highest order.

At the same time the portrait gives a compelling impression
of a living human being. The luxuriousness of the Marquis's
somewhat dissolute character is conveyed through his rather
soft expression, the fluffy painting of the head, and, above all,
through the dog, whose character seems an analogue of that

of his master: especially since the pink and white tones of the face pick up those of the dog's fur across the painting. Titian, as is well-known, loved to paint dogs and they always play a meaningful part in the total content of his portraits.

This portrait of the Marquis of Mantua is one of the more relaxed of Titian's court portraits and, in defence of the Marquis's character, it is only fair to say that Titian also painted him in armour in a way which doubtless emphasized his war-like characteristics and unquestionable bravery. Each of Titian's portraits, indeed, is designed to bring out not only the appearance of the sitter, but a certain concept of his role and status. In the portrait of Alfonso d'Este with his hand on a cannon (version in the Metropolitan Museum of Art, New York), the whole stance of the figure conveys his aggressive character and creates the impression of command. The language of pose and gesture in such portraits is derived by Titian from his study of classical sculpture, and its combination with the colour and painterly freedom of his style of painting gave a new splendour to official portraits, which must have been well-nigh irresistible to the sitter.

At Bologna in 1530, the Marquis of Mantua introduced Titian to Charles V, and in the portraits that he painted of the Emperor, the artist set the pattern for the development of royal portraiture in the next two centuries. The Emperor was a real lover of art who quickly appreciated Titian's genius and used him accordingly. One of Titian's first tasks was to paint a new version of a full-length portrait of Charles V, which had been painted in Germany by the Court Painter, Seiseneger. It was the first time Titian had tackled this form, which was a German invention, and obviously Charles's first wish was for a more lively likeness; but Titian's version, now in the Prado, not only gives flesh and blood to Seiseneger's dry figure but also weaves a kind of physical romance out of the play of light on the green and silver of the Emperor's costume and the relation of the figure to the atmosphere-filled space in which he stands.

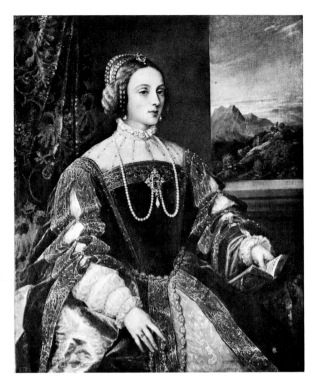

97 TITIAN *The Empress Isabella* c. 1545

The same transcendence of verisimilitude to create a poetic effect is present also in the portrait painted by Titian for Charles of his dead wife, the Empress Isabella, which the Emperor was *Ill. 97* later to take with him into his retirement in the Monastery at Yuste. The picture is, in the Emperor's intention, an act of memory, and the very landscape on the right, cool in tone as opposed to the muted warmth of the rose and purple dress, enhances the mood and becomes a metaphor for the remoteness of the figure herself. Titian had from the beginning sometimes used landscape as a complement to his figures, but here the landscape and the figure are woven together by an infinity of delicate relationships of colour, so that the orange of the evening sky is caught up in her hair and the grey-blue of the distant mountains in her eyes. This is visual poetry of the highest order and with it Titian raises the painting of likenesses to the level of great art.

In 1533 Titian was knighted by the Emperor, and in 1548 he was summoned to attend him at the Congress of Augsburg. This was the moment of the Emperor's greatest political triumph, and by wishing Titian – the Apelles, as he said, to his Caesar – to record it the Emperor gave portraiture an historical as well as a merely social function. The most important product of Titian's period at Augsburg is the equestrian portrait of the *Ill. 98* Emperor, now in the Prado, in which, as a contemporary letter tells us, he is shown in the armour he wore at the Battle of Mühlberg. The battle is not represented, but the landscape conveys its mood, and Titian is here applying to portraiture that dramatic relationship between figures and landscape which he had developed in religious painting in the *Death of St Peter* *Ill. 74* *Martyr*. This is the first royal equestrian portrait, and it starts a tradition which was to be carried on by Rubens, Van Dyck, and Velazquez in the seventeenth century. With Titian indeed, all the main motifs of seventeenth-century court portraiture are established; essentially its story is simply that of the development, on an ever more flamboyant and opulent scale, of ideas which he had invented.

Titian was also patronized by the Farnese family – the greatest of Roman patrons – and, under the Farnese Pope, Paul III, was invited to Rome and lodged in the Vatican. While there, he began his first group portrait, in which the Pope is shown with his 'Nipoti', Ottavio Farnese and Cardinal Alessandro Farnese. The informality of composition and the psychological tensions within the group recall the much earlier *Ill. 99* *Concert*, and suggest that by this time Titian was painting portraits as much for what interested him as to fulfil a commission. As a view of Farnese family life the painting is alarmingly revealing, and it is perhaps not surprising that it was never finished.

Whatever the reasons for its non-completion, the Farnese group is so large in scale that it would have occupied a very dominant position in the decoration of any room in which it was hung. This in itself shows the extraordinary growth in

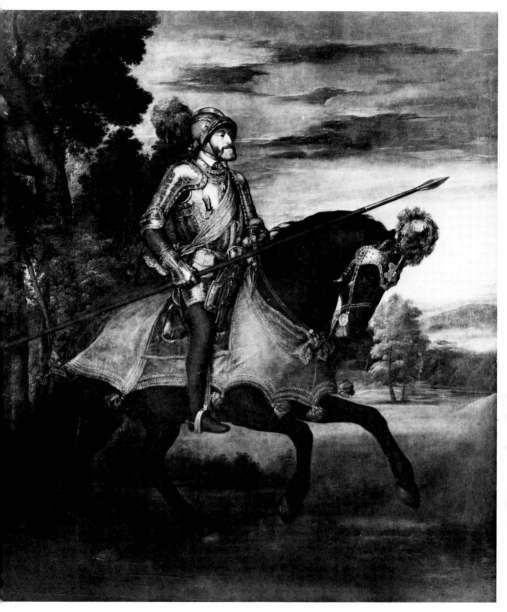

98 TITIAN *Charles V at Mühlberg* 1548. The painting was badly damaged by fire; the horse's legs and the base of the picture are repainted

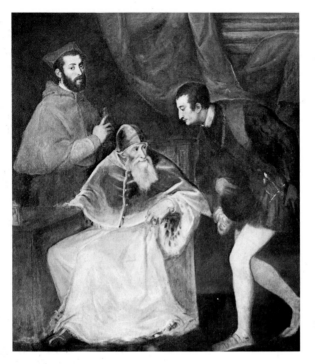

99 TITIAN *Pope Paul III and his Nephews* 1546

100 TITIAN *Portrait of a Nobleman, the so-called Duke of Atri* c. 1550

importance which had occurred in portraiture since the small, bust-length portraits of the Late Quattrocento. We can see this, too, in the scale and sumptuousness of the full-length *Ill. 100* portrait of an unknown man, the so-called *Duke of Atri*, at Kassel. The identity of the stunted little sitter is not certain, but the contrast between him and the magnificence which surrounds him must have been very much in Titian's mind and is an important part of the content of the picture. By this time the artist has made the full-length portrait his own, and he employs the full vocabulary of his late manner, setting the figure against a landscape of immense visual splendour, and linking the two in a flurry of pink and silver paint. All the magic of the interrelation between foreground form and background space, which is the essence of Titian's late work, is present here. It is a masterpiece and intended as such, and in it Titian is pushing his portraiture to the limit of its human and artistic possibilities.

124

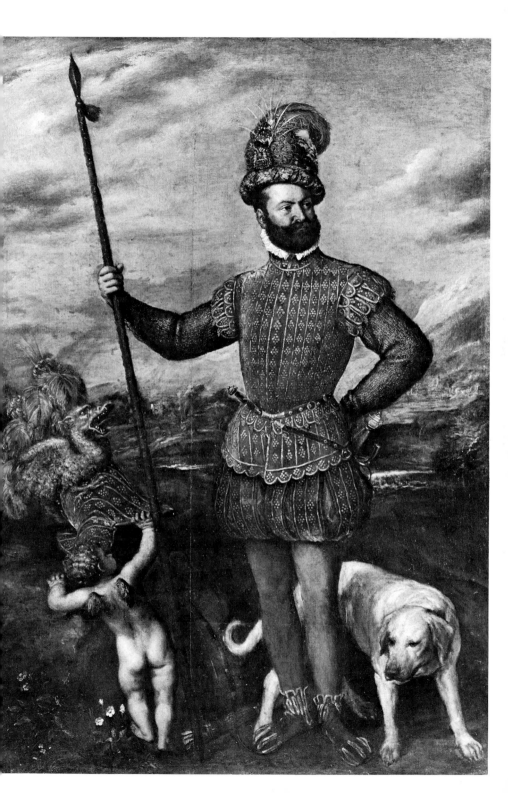

Ill. 101

Others of Titian's late portraits develop simple relationships of colour and texture, similar to those in the *Man with a Glove*, but with a painterly freedom characteristic of the artist's last manner. Even in his very last portrait, the *Jacopo Strada* in Vienna, Titian is still experimenting. Influenced either directly by northern portraiture or by Lorenzo Lotto, he places his figure in an interior and surrounds him with all the accessories of his trade. Strada was a connoisseur, antiquarian and dealer, well known to Titian and it is typical of the inclusiveness and open-mindedness of his old age that he now tackles, for the first time, this kind of action portrait and translates it into his own idiom, reducing everything to the flashes of light and mobile relationships of his late style. Only Rembrandt, with his more profound humanity, could carry portraiture to a higher level.

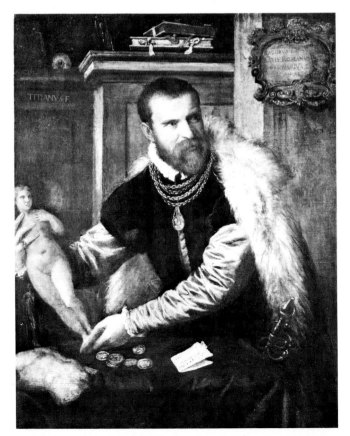

101 TITIAN *Jacopo Strada* 1567–8. Strada, an antique dealer, seems to be displaying his wares to the spectator

102 LORENZO LOTTO *Andrea Odoni* 1527

Of Titian's immediate contemporaries, after of course Gior-
gione, only Lorenzo Lotto approaches him in his understanding
of the potentialities of the portrait. Lotto's portraits, like his
other works, are, as we have already seen in his *Bishop Bernardo
dei Rossi*, highly individual. They convey, over and above
their function as likenesses, an undertow of that inner anxiety
with which he seems to have been afflicted, and are in this
respect somewhat twentieth century in feeling. Starting from
the same premises as Titian, he develops as differently as
possible, painting mostly horizontal portraits, often of more
than one figure, set in realistic settings with a high degree of
naturalistic detail, which was probably inspired by northern
engravings. But, like Titian, he builds a unified concept out of
all these elements. In the broadly painted *Andrea Odoni* at *Ill. 102*

127

Ill. 103

Hampton Court, the warm rich shadows, the loose handling, and the rich texture of the objects themselves convey a certain expansive opulence of taste, not unmixed, however, with neurotic anxiety. The *Della Volta Family* on the other hand has a naïve intimacy reminiscent of the Douanier Rousseau. The figures are either frontal or in profile, and the obsessive minuteness of detail is almost emblematic. The square of the landscape thrust between the two heads has a very strange effect: its misty, slightly lonely distance becomes inevitably associated with the figures and part of the total mood of the painting. Such painting is as much about the artist as about the sitters, and its strange tensions are explicable only as the personal expression of a highly individual genius.

103 LORENZO LOTTO *Giovanni della Volta with his Wife and Children* 1547

104 TINTORETTO *Man with the Gold Chain c.* 1550

105 TINTORETTO *Self-portrait in Old Age c.* 1590

Tintoretto and Veronese, Titian's younger contemporaries, both painted portraits of high quality, but did nothing to add to the range of his achievement. Tintoretto early developed a formula for the mass-production of portraits, and there are many competent but rather dull portraits of senators and other Venetians from his studio. Hardly ever leaving Venice, he did not develop a court style; his colours are always muted and his effects simple. At his best, in the portraits from his own hand, such as the *Man with the Gold Chain*, he achieved straight-forward compositional harmonies of light and texture comparable to Titian's work of the period of *Man with a Glove*. Tintoretto's portrayal of character is rarely profound, except in his own self-portrait in the Louvre, whose blunt frontality and blazing eyes are an extraordinary record of that visionary intensity which inspired his great religious works.

Ill. 104

Ill. 105

Veronese's portraits also are an extension of his other painting. On the whole they convey little effect of character and seem mainly designed to express in general terms his ideal of aristocratic assurance and ease. Their positive qualities, rich and integrated colour and great suavity of form, are those of all his works. Following Titian, he painted full- and three-quarter-length portraits, and his most original achievement was to place the sitter against monumental architecture, ennobling him by his association with a setting on a scale grander than himself: a device which was to pass into the vocabulary of seventeenth-century portraiture. He does this in the *Young Nobleman*, where the asymmetrical arrangement is typical of Veronese's manner in full-length portraits. The young man leans languidly on the plinth, but we are fascinated not so much by his character, which seems fairly nebulous, as by the pictorial values of the range of blacks in his clothes and the infinite interplay of warm and cool tones by which Veronese makes even the neutral architecture seem redolent with colour.

Ill. 106

106 VERONESE *Young Nobleman*

107 ALESSANDRO LONGHI *The Procurator Daniele Dolfin*

108 GIOVANNI BATTISTA TIEPOLO *Giovanni Querini c.* 1749

The history of the Venetian portrait in the seventeenth and eighteenth centuries is relatively straightforward. Until the mid seventeenth century Palma Giovane and the Bassani continued to produce portraits in the tradition of the preceding period, and it was not until after 1663, when Sebastiano Bombelli (1637–1716) settled in Venice, that a more solid realism, with a seventeenth-century simplification of the background to emphasize the figure, entered Venetian painting. Sebastiano Bombelli set a tradition of full-length patrician portraiture, mostly of figures in senatorial robes, which lasted until the end of the Republic. Alessandro Longhi (1733–1813) *Ill. 107* goes beyond this to a more varied portraiture which has an elegance and an imaginative richness in the relationship between the figure and the setting sometimes reminiscent of

131

Reynolds, whom he influenced. But only Tiepolo, in his awe-
Ill. 108 inspiring *Giovanni Querini*, produced anything in this genre to
match the magnificence and profundity of sixteenth-century
portraiture.

Internationally the most important of Venetian eighteenth-
century portraitists is the pastel painter, Rosalba Carriera
(1675–1757). As well as straightforward likenesses, which have
a sweet, surface elegance, but little concern with depth of
Ill. 109 character, she painted idealized figures of pretty women in a
variety of allegorical roles, which are really a translation of the
Giorgionesque 'fancy portrait' into a Rococo idiom. This style
won her great popularity abroad, especially in France, which
she visited in 1720, and her presence in Paris at that early date
encouraged the development of French Rococo painting in the
work of such artists as Boucher and Greuze. Through her, as
through the impact of the works of Alessandro Longhi on
visitors to the city, Venetian portraiture continued, during the
eighteenth century, to play a part in the development of
European portraiture as a whole.

109 ROSALBA CARRIERA
An Allegory of Fire

The latter half of the sixteenth century

By the mid sixteenth century Venetian Renaissance painting
had developed a dynamic of its own so strong that it survived,
despite the *longueurs* of the seventeenth century, until the end
of the Republic. From the 1540s there was renewed influence
from the art of Central Italy, but Venetian artists, although
affected by the aims and attitudes of the Central Italian style
known as 'Mannerism', were able to reformulate it into their
own terms. It is in this period, between 1550 and the end of the
century, that the most individual characteristics of Venetian art
– colour and the free handling of paint – reach their fullest
development. They find complete expression in the late work
of Titian and are taken individually to new heights by Veronese
and Tintoretto respectively.

Titian, as was seen in the last chapter, had entered in the
thirties and forties the most international phase of his career.
He worked at this time mostly for princely patrons, and a new
delicacy and refinement in his style probably reflects their
taste. From about 1530 his painting becomes more minutely
detailed. There is no loss of painterly softness but the strokes
become small and crisp, and the jewel-like finish of his style
in this period has caused it to be known as his 'Flemish' manner.
He painted few large altarpieces in the thirties, and his religious
works are mostly small, delicate cabinet pieces, like the *Virgin
of the Rabbit* in the Louvre or the *Virgin and Child with St
Catherine* in the National Gallery, London.

The *Presentation of the Virgin*, although not a cabinet picture, *Ill. 110*
shows this detailed manner. It was painted in the mid 1530s
for the Scuola della Carità, which has since become the Galleria
dell'Accademia, and so, by a fortunate chance, it still hangs in
the position for which it was designed, although a hole has

133

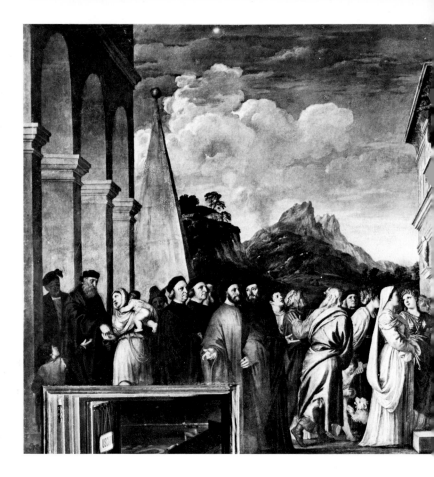

been vandalistically cut in the left-hand side to make room for
an extra door. It is Titian's only essay in the kind of narrative
painting which decorated the Scuole, and his awareness of its
traditions is shown in the old woman with the basket of eggs
on the right, a figure directly quoted from a painting by
Carpaccio. The crowd of figures (many of whom are probably
portraits), their small scale relative to the architecture, and the
processional format of the composition are also in this tradition,
and Titian gives a characteristic flavour of Venetian topography
to the scene by the diamond pattern of the pink and white
bricks on the background wall, which recalls the Palazzo

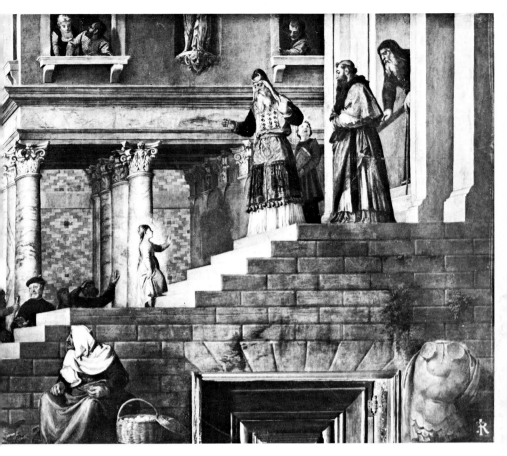

110 TITIAN *Presentation of the Virgin* 1534–8

Ducale. On the left a spacious mountain vista recalls a specific range of the Dolomites well known to the artist.

But for all its traditional approach to narrative and topographical detail, Titian's painting is very much of the sixteenth century in the ultimate subordination of all this to the dramatic content of the scene. The tiny figure of the Virgin is so placed that she is the focus of the whole composition and, with a brilliant decorative and dramatic sense, Titian has painted her in blue encircled by a halo of gold; two colours which appear nowhere else in the painting, but which are picked up in the carved and gilded ceiling of the room itself.

135

The *Presentation* shows Titian bringing a traditional Venetian form up to date. But in the succeeding decade his style is affected by external rather than internal influences, as he comes to grips with the powerful forces of Central Italian Mannerism. He must have had some knowledge of the struggling figures of Titans overwhelmed by rocks painted by Giulio Romano, the pupil of Raphael, in the Sala dei Giganti of the Palazzo del Tè, at Mantua, and by 1540 Mannerist painting was also to be seen in Venice itself. The Florentine Francesco Salviati visited the city between 1539 and 1541, and painted there an altarpiece for the new Church of S. Spirito, which was being built by another Florentine, Jacopo Sansovino. This church, which was something of a point of focus for the new style, was to have had a ceiling painted by Vasari, and it is significant that when Vasari reneged from the commission Titian took over. His three Old Testament scenes, painted for S. Spirito but now in the Sacristy of S. Maria della Salute, show gigantic nude figures in violent action and are very reminiscent of Giulio. As a stage in Titian's development they cannot be accounted for except in terms of outside influence.

The violence of these scenes reflects the general pessimism which swept over Italy as a result of the Sack of Rome and the pressures of the nascent Counter-Reformation. Although Venice was less subject to these tensions than the rest of Italy, Titian's paintings from the forties onwards clearly show a loss of confidence in the values of his earlier works. They are far *Ill. 111* less hedonistic, confident, and secure. In his *Mocking of Christ* in the Louvre, the sensuous vigour of his earlier dramatic scenes, such as the *Death of St Peter Martyr*, is replaced by an agitation altogether more extreme. Among the figures there are no horizontal or vertical lines: everything is angular and turbulent and the physical brutality is heightened to screaming-point.

This painting also shows a new fascination for the sculptural values of Central Italian art, which is perhaps due to the growth of connoisseurship in the middle of the century and an

136

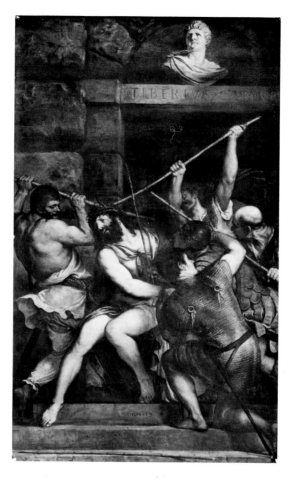

111 TITIAN *The Mocking of Christ* c. 1542–7

increasing awareness by each school of the values of the other. Titian himself was a friend of the connoisseur and critic Pietro Aretino, who, while a strong supporter of the Venetian school and of Titian in particular, well understood the virtues of Roman art and encouraged Titian to visit Rome. At this period Titian seems to have taken a fresh look at classical sculpture, especially at the struggling figures of the *Laocoön* whose tense interlocking movements are certainly recalled in the group in the *Mocking*. Titian had already been influenced by this work much earlier in his career, but this time he retains much more

137

of the sculptural sharpness of his model. It may be significant, too, that almost alone of Titian's works the *Mocking* is painted on panel, not canvas. The smoothness of the surfaces encourages the sculptural effect of the forms and makes the picture the most plastic of all Titian's works.

Yet for all this, there is a weightlessness about the figures of the executioners and a general subordination of the volumes to the total rhythm of the composition which is completely un-Roman. While Titian was staying in the Vatican in the winter of 1545–6 as the guest of the Farnese, he was visited by Michelangelo, accompanied by Vasari. Michelangelo praised his work for its reality, but remarked afterwards to Vasari that Titian would indeed have been a truly great artist, if only he had learned to draw! Drawing for Michelangelo meant essentially the definition of form by line as a means of expressing its three-dimensional solidity and mass, and the remark shows how irreconcilable the attitudes of the two schools really were. Looking in this light at the *Mocking*, it is easy to see how Michelangelo could never have accepted the kneeling executioner on the right, whose body is pulled round into the plane, or the very individual and un-Classical proportions of the figures who, flattened by the light, become merged into a whole. Even at this most Roman moment of his art, Titian's approach to form is essentially pictorial.

After 1551 – the date of his return from a second visit to Augsburg – Titian settled down in Venice and remained there until his death at an advanced age in 1576. He had by now worked through the renewed influence of the Roman school, and in these last twenty-five years he returned to an exploration of the visual foundations of his own art. His late style is, within the context of this book, comparable in kind only to that of Bellini. It is both deeply personal and the most profound expression of the kind of visual and pictorial experience which is the essence of Venetian art.

Titian was fortunate in these last years in having Philip II of Spain as his patron. From the State pension which he received

138

from the King, as well as from his investments, he enjoyed financial security (although he constantly fretted about money), and his immense prestige enabled him to paint as he liked. It must be said too that Philip was a patron of discernment, who was prepared to support his chosen painter even into the strange pictorial explorations of his old age.

The largest group of works painted by Titian for the King is a series of mythologies, with subjects taken from Ovid. These are entirely different from the sensuous and humane mythologies of Titian's earlier years. They are all scenes of violence and show, among other subjects, Actaeon torn to death by his hounds for accidentally spying on Diana; the chastisement of the nymph Callisto who, unknown to herself, had been made pregnant by Jove; and the rape of Europa. In them Titian lays bare the torments of the flesh and the injustice of the gods but, by transmuting the passions of existence into the beauty of paint, seems to accept and transcend them. Contrasts, both visual and emotional, are pushed to extremes, but are also reconciled and brought together by the artist's vision itself.

In the *Diana discovering Callisto* and the *Diana surprised by Actaeon* (both on permanent loan to the National Gallery of Scotland, Edinburgh), the theme, as in his earlier mythologies, is still figures in landscape. But whereas in the *Bacchus and Ariadne* of 1523 many of the figures, and especially Ariadne herself, have individually the internal harmony and balance of Antique statues, here, in these works of the late fifties, the movements of the figures are resolved only by their relationships within the tense balance of the composition as a whole. We see how, in the *Diana surprised by Actaeon*, the composition is given a deliberate instability by the tilting of the cistern, and how the figures of Diana and Actaeon pull away from one another across the painting, so that the whole surface becomes alive with tensions which convey the content of the subject. The landscape too – a continuous range of storm-flecked mountains glimpsed between the trees – is activated, from left

Ills. 112, 113

Ill. 113

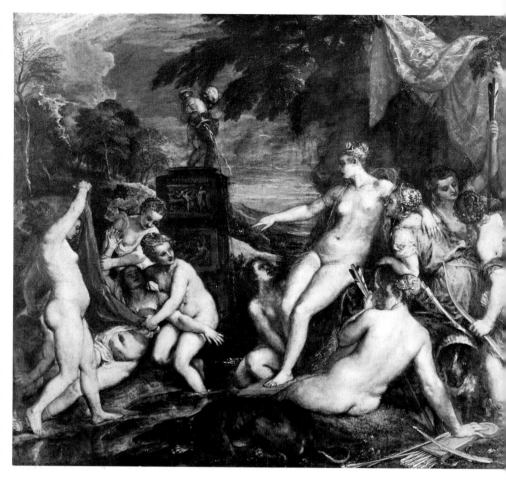

112 TITIAN *Diana discovering Callisto* 1556–9. The nymph Callisto who unknown to herself had been made pregnant by Jove, is discovered and condemned by Diana

to right, by a fleeting glimpse of a maiden hunting a stag, and complements, in its natural drama, the tensions of the scene.

This style is full of anguish and conflict, and yet, through Titian's handling of colour and paint, it has a passionate visual beauty which gives it another dimension. In the *Diana and* *Ill. 116* *Actaeon* a cloth of glorious pink joins the foreground to the mountain landscape, while in the *Diana and Callisto* the figures

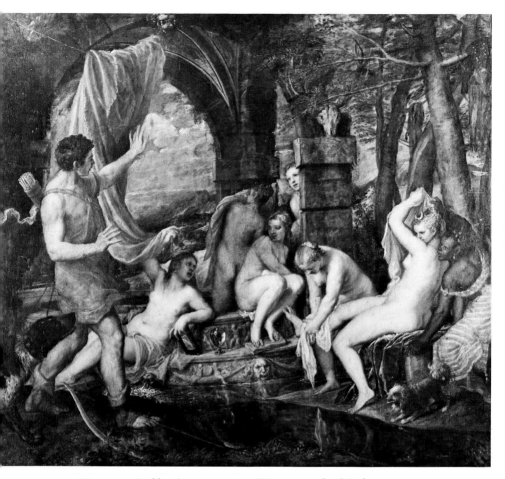

113 TITIAN *Diana surprised by Actaeon* 1556–9. Diana starts back in horror at
Actaeon's unexpected arrival. She later turned him into a stag and he was
torn to death by his own hounds

seem painted in molten gold, and link in a frenzy of glowing
colour with the stormy sky. All the parts of the painting are
interconnected by colour and surface texture, and by means of
this ravishing pictorial unity the extreme tensions of the subject
are not so much resolved as transmuted to another level of
experience. It is as if the ageing painter was able to face all the
anguish and suffering of human existence and by the force of

141

his visual imagination to transcend it. In this marvellous acceptance of opposites lies the message of Titian's late work. In the manner in which they are actually painted the Edinburgh mythologies, although dated only at the beginning of Titian's late period, already show the freedom and economy of his late manner, in which the painterly qualities of Venetian art were brought to their fullest development. A warm reddish ground shows through over large areas of the canvas and the forms are suggested rather than defined by a complex of open brush-strokes, which appear rapid and spontaneous and are

Ill. 112 very varied in texture. The dog on the right of the *Diana and*

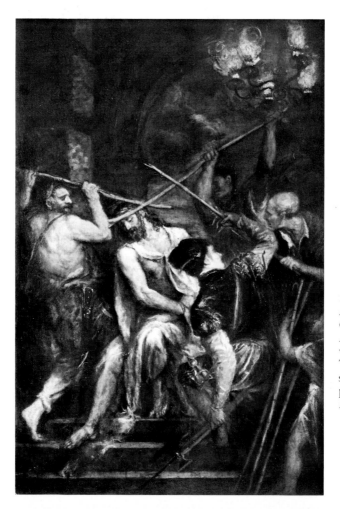

114 TITIAN
*Mocking of
Christ c.* 1570.
A second
version in
Titian's late
style of the
painting in
Ill. 111

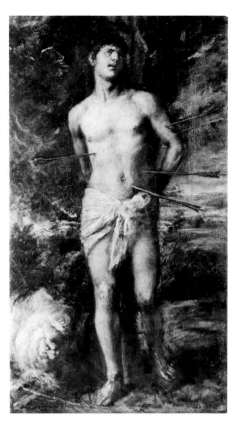

Callisto is created mainly from a few patches of roughly impasted paint, which, set against the warm tone of the ground, are enough to evoke with complete conviction the whole form of the animal. The illustration shows in a more detailed passage the complexity of Titian's brush-work and his use of glazes and superimposed layers of paint to build up the final effect. His understanding of the way we see is now such that he uses the spectator's expectations to create form for him, rarely defining what it is necessary only to suggest. His brush-work is, by this means, released from the necessity of charting form precisely and acquires a freedom and a life of its own which becomes part of the expressive language of the picture.

Ill. 116

Apart from the evidence of the paintings themselves, we know something of the way Titian worked in his last years

from the description of his pupil Palma Giovane, who completed his final work, the *Pietà* now in the Accademia, Venice. Palma tells us how Titian painted his late works in stages, first laying in the main forms with a few strokes on the warm ground, and then turning the canvas to the wall, returning to it again only after many months to add a stroke here or there, altering and revising repeatedly. For this reason it is difficult, in the case of works which were in Titian's studio at his death rather than delivered to a patron, to know for certain whether they are finished or not, and it is perhaps more important to realize that, as in the case of the late sculptures of Michelangelo, the very newness of the artist's method of working makes traditional ideas of finish irrelevant.

Ill. 114 Such a late 'unfinished' work is the *Mocking of Christ* at Munich. This repeats the composition of Titian's earlier painting of the same subject in the Louvre, and is one of several cases in which Titian, rather than create a new composition, reconceived an old one in his new manner. It shows the development that Titian's style has undergone since the mythologies of the late fifties. There, the distinction between form and space still exists and the form of the figures remains partly sculptural: here, this distinction has almost disappeared. The forms emerge like wraiths out of the circumambient darkness, and mass is reduced to a flickering pattern of colour and light. In his last years only these elements had reality for Titian.

Ill. 115 In the Leningrad *St Sebastian*, a figure, whose form and proportions refer back to Michelangelo, is translated into a smouldering mass of light. The Saint is one with the landscape and the sky and the distinction between matter and spirit is abrogated by the unifying power of the painter's vision. Yet within the visual splendour the pain and the suffering remain.

Ill. 117 The Vienna *Nymph and Shepherd*, an idyllic subject from Titian's earlier years, takes place in a landscape molten with passion, while in the background a stag tears savagely at the bark of a tree. It is out of the whole of experience, pain and beauty together, that these paintings are made.

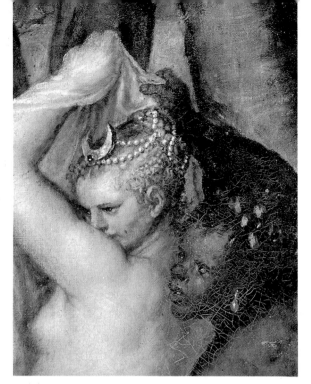

116 TITIAN *Diana surprised by Actaeon* (detail)

117 TITIAN *Nymph and Shepherd*. A late work

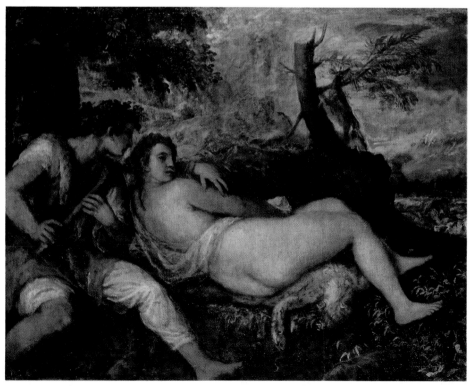

Jacopo Bassano (1517/18–92), Jacopo Tintoretto (1518–94), and Paolo Veronese (c. 1528–88) are the major masters of the second generation of Venetian sixteenth-century painters. For them, and for a mass of minor figures as well, Titian's mature style was fundamental, even if their immediate response was to argue against it. At the same time Central Italian Mannerism, which had affected Titian himself in the forties, also attracted the younger generation. They were well able, however, to make from it something of their own, and if there are qualities in later sixteenth-century painting which can helpfully be defined as 'Mannerist', they are Mannerist in a specifically Venetian way.

Of the three main figures, Jacopo il Ponte, called Bassano, comes nearest to being a Mannerist in the Central Italian sense. The attenuated elegance of his elongated figures and the arbitrary way in which, in his middle period, he constructs space show his kinship with artists otherwise as diverse as Pontormo, Rosso, Parmigianino, and El Greco. He was probably, through the medium of engravings, directly influenced by Parmigianino, and he himself influenced El Greco, so he has an important place in the history of the style.

Jacopo Bassano is the central figure in a school of painters which flourished for three generations in the provincial capital of Bassano and which, since it was founded by his father Francesco and carried on by his own sons, was effectively a family affair. He himself was trained in Venice, by Bonifazio Veronese, and although he worked mostly in his native province he is, in quality and originality, very far from being a provincial artist.

Even his early work is very individual. It seems to have been influenced partly by his father and partly by Pordenone and Lotto, who worked extensively in the provinces north of *Ill. 118* Venice, of which Bassano is one. The *Adoration of the Magi* in the National Gallery of Scotland, Edinburgh, goes beyond these masters in the buttery richness of the paint and the very personal way in which Bassano, painting in bright patches of

118 JACOPO BASSANO *Adoration of the Magi*. Early 1540s

colour, pulls all the forms into a jigsaw-like pattern on the surface of the painting. This style denies space in an arbitrary way and seems even at this early stage to be an equivalent, in Bassano's own terms, for the spacelessness of Mannerist painting generally.

By the late forties and early fifties the influence of Parmigianino, and also of Francesco Salviati, whose visit to Venice has already been noted, can be seen directly in Jacopo Bassano's work, and is clear in the *Decapitation of St John* at Copenhagen. *Ill. 119* His colour at this time becomes very astringent – the *Decapitation* contains hot ochre and acid-green, adding to the uneasy

147

tension of the forms. A mood of anxiety is created, not by telling the story in a dramatic way, but by the rootless intensity with which the figures gaze at one another or rush in and out of the picture. In these circumstances the very elegance of their forms and attitudes becomes a cause of disquiet.

In the 1560s Jacopo turned his back on this style and re-asserted, probably under the influence of Veronese, the monumental values of Venetian art in the third decade of the century; the period in which Titian painted the *Votive Picture of the Pesaro Family*. He also followed Titian and Tintoretto in subordinating local colour to light and shade, and evolved a highly original chiaroscuro in which subdued, rather smoky colours emerge evocatively from gritty darkness.

Ill. 120 The *Adoration of the Shepherds* in the Museo Civico at Bassano, one of the key paintings in this style, also shows a new monumental rusticity which is probably Jacopo's most influential contribution to the history of art. The peasant figures, for all the grandeur of their forms, have wrinkled skins and muddy feet, and animals are much in evidence. All the dirt of the farmyard now finds its way into monumental painting, and this kind of material realism, new in Venetian painting, was to have an important influence on Caravaggio when, at the end of the century, he set out to bring reality and truth back to the grand manner.

This rural subject-matter, treated for its own sake, is also the basis for a new genre of rustic pastoralia, much practised by Jacopo's sons, Francesco and Leandro, who continue it into the seventeenth century. It is seen at its most poetic in Jacopo's own *Ill. 122* late *Terrestrial Paradise*, painted with light, flickering, calligraphic highlights in the open style of his last years. Unhappily this style was quickly hardened by his sons into a formula, and specimens of it are drearily recurrent on the walls of almost every sale-room.

The poetic subject of the Holy Family seated, with or without saints, in a landscape, which Titian had perfected in the thirties,

148

119 JACOPO BASSANO *Decapitation of St John the Baptist*. Bassano at his most
Mannerist

is taken up by a number of artists in the next two decades. In
the work of Paris Bordone (1500–71) it is treated with some *Ill. 121*
originality. The landscapes have a certain picturesque wildness,
the figures twist and turn, and he uses rather dramatic colour-

120 JACOPO BASSANO *Adoration of the Shepherds* 1568

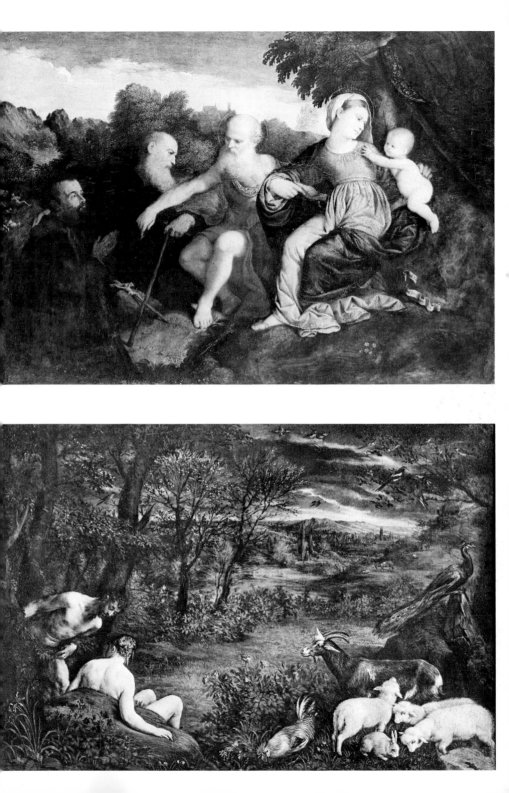

schemes based on the contrast of indigo-blue with purplish red. All this agitation is Mannerist in flavour, and the same qualities can be seen in the work of Andrea Schiavone (1522–63), who specialized in small-scale horizontal narrative scenes, often intended as furniture paintings. Schiavone developed a fluent manner of handling paint, with strong contrasts of light and dark and loose highlights painted with a loaded brush. His *Ill. 123* *Giorgio Cornaro on Horseback* at Crichel shows this style on a much larger scale, with a strongly Mannerist jump from the foreground to distant space and Flemish influence in the landscape. This style, which is very close to Tintoretto, indicates the way in which a new generation, dedicated more to striking effects than painstaking observation, was developing the painterly tradition which Titian had established, towards a kind of visual shorthand, which could be rapidly executed and was effective at a distance.

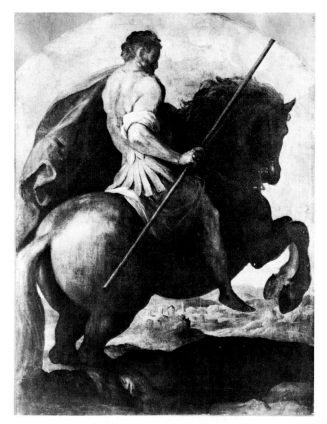

123 ANDREA
SCHIAVONE
*Giorgio Cornaro
on Horseback*

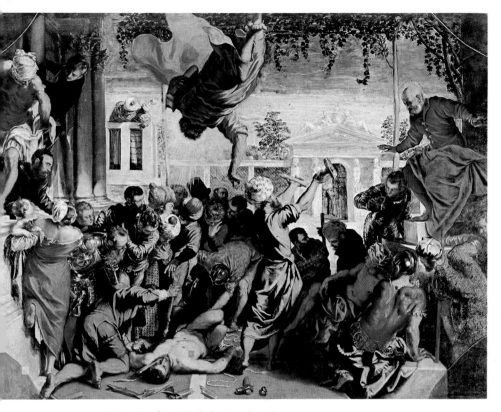

124 TINTORETTO *Miracle of St Mark freeing the Slave* 1548

Jacopo Tintoretto, the great master of this summary style, was in every respect Titian's antithesis. He was and remained a bourgeois who, far from moving in cosmopolitan society, only once left Venice. He had indeed few princely patrons and painted almost exclusively within the city.

Yet visually Tintoretto's painting was sophisticated in a new way. He painted in a climate of taste in which style as such was beginning to be appreciated for its own sake, and his works were designed to attract attention and to make an effect. They have sometimes more to do with picture-making than with visual observation, but they are endlessly inventive and are projected, with a liberating freedom of gesture, on canvases

whose very size gives a new scale and generosity to Venetian painting.

Tintoretto made his reputation in 1548 – a year, significantly, when Titian was away from Venice – with his *Miracle of St Mark freeing the Slave* for the Scuola Grande di S. Marco. Its bravura brush-work is of dazzling brilliance and the bright sharp colours (now restored to their original intensity by a recent cleaning) seem intended as a deliberate contrast to the more subdued harmonies of Titian's work at the same time. The space is defined by the perspective of a curious box-like pergola, from which the dramatically foreshortened figure of the swooping saint almost seems to be suspended. Probably it actually was, for Ridolfi tells us that Tintoretto composed his pictures by moving and suspending model figures in specially constructed boxes.

Ill. 124

In this treatment of form and space Tintoretto seems to be trying to combine Roman and Venetian ideals in a new and daring synthesis, but in fact the final result has a style all its own. Because of the detached brush-strokes the figures are not solid enough to create space sculpturally and the local colour is too bright to allow atmospheric perspective. As a result there is a lack of reality about the space and an absence of substance in the forms. The final result is not so much about reality as about making a picture; but it is picture-making of the most brilliant kind.

After the painting *St Mark freeing the Slave*, Tintoretto applied himself to transforming the churches and public buildings of the city in a long series of large-scale paintings, very rapidly executed. By the speed at which he painted he aroused the jealousy of his fellow painters and the censure of so distinguished a critic as Aretino, but it was essential to his aim. Scale was of the essence of his art and the east end of the Gothic Church of the Madonna del Orto was, for example, completely transformed by the enormous paintings he set into it, the windows being blocked up for the purpose. Such canvases were a new form of decoration in Venetian churches and started a

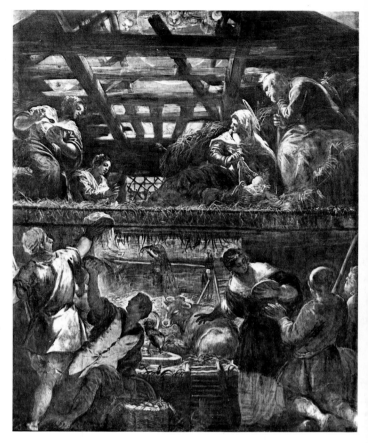

125 TINTORETTO
Nativity 1576–81.
An example of
the painterly
shorthand which
Tintoretto used
in his scene for
the Upper Hall
in the Scuola di
S. Rocco

fashion which continued through the seventeenth and eighteenth centuries.

The Scuole, however, provided the most obvious field for Tintoretto's decorative talents, and between 1564 and 1587 (the major part of his working life) he was at work in the Scuola di S. Rocco, evolving a complete cycle of painted scenes, in which the walls of all three halls of the Scuola are entirely covered with canvases. Architectural decoration is confined in the two upper halls to the magnificently carved and gilded ceilings, and even these are settings for further paintings. Because of this predominance of canvas one still cannot speak of an integrated

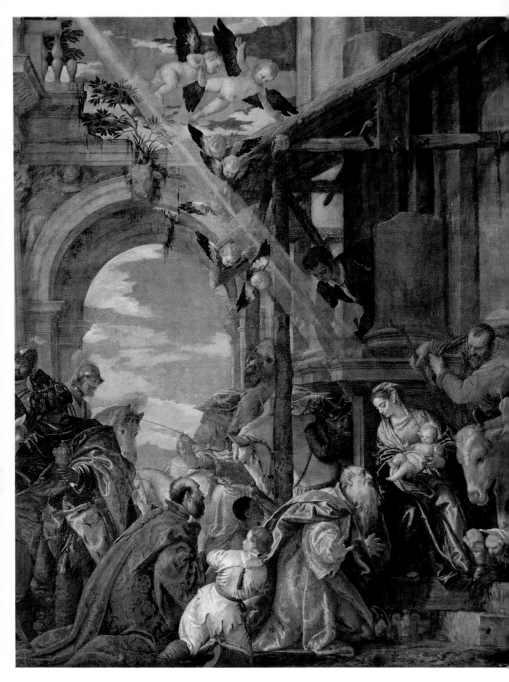

126 VERONESE *Adoration of the Magi* (detail) 1573

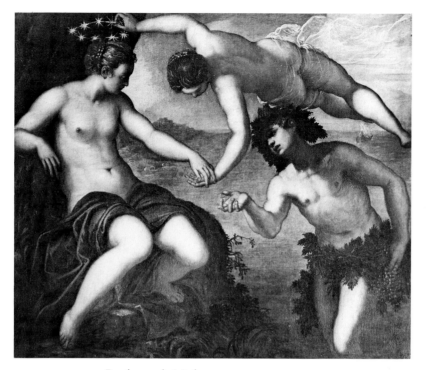

127 TINTORETTO *Bacchus and Ariadne* 1577

decorative relation between the paintings and their setting, and Tintoretto's approach to decoration remains essentially that of encrustation (which we noted in an earlier chapter as characteristically Venetian), although encrustation carried to extremes. The building is simply swamped by the paintings with which it is decorated.

The largest painting in the Scuola di S. Rocco, which belongs to the first stage of the decoration and was painted in 1565, is the *Crucifixion* in the Sala dell'Albergo. In its multiplicity of incident it is in the tradition of the narrative paintings of the Scuole, going back to Jacopo Bellini, but Tintoretto so masses the many parts of the composition that they have a dramatic focus. All the groups revolve round the pyramid of figures at the foot of the Cross, and skilfully-organized diagonals

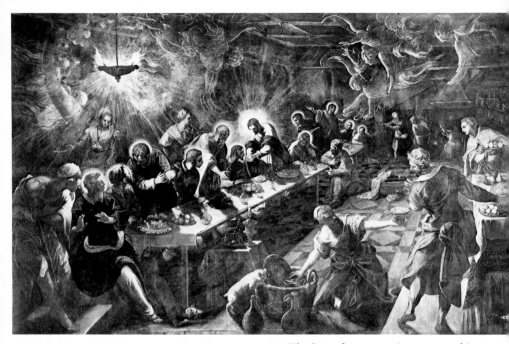

128 TINTORETTO *Last Supper* 1592–4. The last of many variants on a subject which Tintoretto painted throughout his life

Ill. 129 lead the eye upwards to the isolated figure of Christ. A visionary light envelops the whole scene and gives it spiritual meaning. In this setting the incandescent highlights, which Tintoretto had already used in *St Mark freeing the Slave*, have a new purpose and become a vital agent in the spiritualization of form.

This incandescent style is carried still further in the Upper Hall itself, which is painted with scenes from the New Testament typologically related to Old Testament subjects on the ceiling. The main canvases are placed between windows and Tintoretto must have realized that they would not be visible at all unless painted in very clear contrasts of light and dark. The compositions are Mannerist in their boldness and asymmetry, for Tintoretto makes use of dramatically broken vistas and sudden jumps into space. The figures, painted in shining snails' trails of paint, emerge from the warm ground as luminous wraiths rather than substantial forms.

158

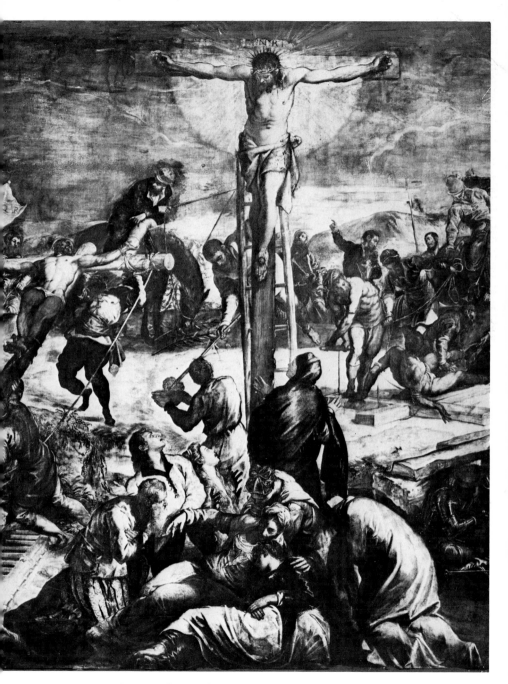

129 TINTORETTO *The Crucifixion* (detail) 1565, the centre of the huge painting which hangs over the benches of the Officers of the Confraternity in the Scuola di S. Rocco

In all his religious paintings Tintoretto made the scene both as spiritual and as real as possible, and to this end he entirely re-thought the traditional approach to each subject, often producing a wide range of different interpretations of the same *Ill. 125* scene. The *Nativity* in the Upper Hall is, for example, completely new in conception. The event takes place at two levels in a broken-down barn, and spiritual light blazing through the rafters transfigures every object, turning even the straw, the hens, and the other animals to fire.

Ill. 128 The summation of this style is the *Last Supper* in S. Giorgio Maggiore, a very late work which was painted between 1592 and 1594. The deep perspective space is filled with dusky atmosphere and peopled by insubstantial angelic forms. Here Tintoretto develops to the full the range of the oil medium, stretching to the limit the possibilities for dematerializing and yet retaining form, which Titian had suggested by the angels at the edges of his *Assumption*.

It is part of his own stylistic self-consciousness and that of his period that, under different circumstances, Tintoretto paints *Ill. 127* in different styles. The *Bacchus and Ariadne*, one from a set of four mythologies in the Palazzo Ducale, is much more solid in style than the scenes in the Upper Hall of the Scuola di S. Rocco, although painted at the same time. Its firmly modelled figures are grouped almost sculpturally in the foreground, against an aqueous space of misty blue. Both the Classical subject-matter and the closeness from which the painting would be viewed required a style more minute and more respectful of human form than that of the Upper Hall.

Elsewhere in the Palazzo Ducale, Tintoretto paints on an epic scale. His canvases are part of the general redecoration of the upper floors of the palace, which took place after the Quattrocento decorations had been burned in the disastrous fire of 1577. Tintoretto matched the challenge of the occasion. *Ill. 130* The *Paradise*, which he painted on the wall above the benches of the Signoria in the Sala del Maggior Consiglio, is the largest oil-painting in the world, and his treatment of the historical

160

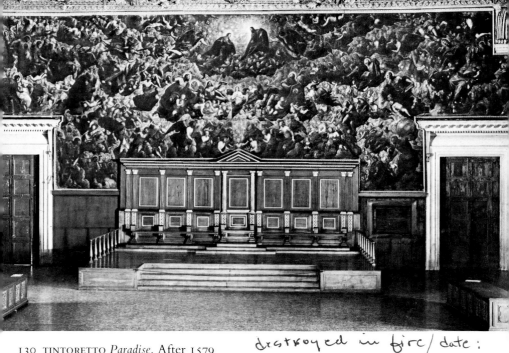

130 TINTORETTO *Paradise*. After 1579 destroyed in fire / date :

scenes allotted to him gave a new dramatic vigour to history painting. To all the traditional forms of Venetian painting Tintoretto gave a new vitality and scale, creating an idiom so powerful and easy to handle that it was continued by his followers, with an increasing decline in quality, right through the succeeding century.

Paolo Veronese (*c.* 1528–88) was born, as his name suggests, in Verona, but although he was trained initially in his native city he had already settled in Venice by 1555. If colour is the most characteristic quality of Venetian art, then Veronese is the most essentially Venetian artist of his period, for, unlike Titian and Tintoretto, who in the sixties subdued colour to chiaroscuro, he remained always first and foremost a colourist. In a sense his paintings are the truest successors to the late works of Giovanni Bellini, for like the aged Bellini he thought of his canvas as a kind of carpet or tapestry of interwoven colours. His approach is, however, more decorative than that of Bellini and the idiom of his paintings, of course, heroic and classical.

Veronese's compositions are strongly influenced by Mannerism and show that he knew the work of artists like Giulio Romano and Parmigianino, as well as Titian's paintings of the forties. However, he rarely left the Veneto, and the Mannerist elements in his work are absorbed into a scheme of values which is entirely Venetian. As a composition his *Feast in the House of Simon* is turbulent and asymmetrical in arrangement, but there is a muting of drama and a reposeful opulence about it which express a highly-developed hedonism. It conveys a patrician ideal of noble persons in a splendid environment, acting out great events with aristocratic ease.

Ill. 131

Such feast scenes are not, of course, about Venetian life as it was actually lived, either in the sixteenth century or at any other time, but like the paintings of Carpaccio they embody, at an imaginative level, an ideal of physical beauty and material splendour which, in the final analysis, is part of Venice's inheritance from Byzantium. In their scale, their grand, rather fanciful architecture, their crowd effects and richness of detail they belong to the tradition of decorative painting for the Scuole, but they are in fact a new kind of subject developed as an appropriate decoration for the refectories of the greater monasteries. In a religious context their expansive hedonism, especially that of Veronese's canvases, is something new. The secularization of religious art could scarcely go further.

Veronese was in fact censured by the Inquisition for the inappropriateness of one of these feast scenes – a *Last Supper* for SS. Giovanni e Paolo – but the Inquisitors were concerned with the details rather than the whole and he did not in the end alter the picture, only changing the subject to *The Feast in the House of Levi* where the great concourse of figures might be felt to be slightly less inappropriate. The record of Veronese's replies to the Inquisitors shows how little he was concerned with the narrative content in these 'Feasts' and how exclusively preoccupied with beauty of pictorial effect and variety and liveliness of action. 'We painters', he said, 'take the same licence as poets and jesters take. It – the picture – is large and it seemed

131 PAOLO VERONESE *Feast in the House of Simon* 1560, from SS. Nazaro e Celso, Verona

to me it could hold many figures.' The glorification of the city remained an essential part of her artists' functions and to this task Veronese was ideally suited. His paintings for the Palazzo Ducale are the supreme examples of his work in this field. In his *Apotheosis of Venice* not only the spirit but also the icono- *Ill. 133* graphy is entirely secular. No saints or angelic figures impinge on the central figure of Venice herself, confident and substantial, who, under an open portico supported by twisted columns, commands the composition. The columns are a boast in themselves, for they were originally an Imperial symbol and had been used in Christian times only in St Peter's itself. Their presence here asserts the city's own consciousness of its dignity and importance.

163

132 VERONESE *Allegorical Figures and a Servant c.* 1561, one of the delightful pieces of illusionism for the Villa Barbaro at Maser

Ill. 133 The *Apotheosis of Venice* is a ceiling painting – the central decoration of the Sala del Maggior Consiglio, one wall of which is occupied by Tintoretto's *Paradise* – and is the centrepiece of a deeply carved and gilded frame, divided into geometric compartments, each occupied by a separate scene. This kind of ceiling, which is found often in the Palazzo Ducale and in the sixteenth-century Scuole, has great plastic richness. To fit it, Veronese perfected a typically Venetian form of ceiling

164

133 PAOLO VERONESE *Apotheosis of Venice c.* 1583

134 PAOLO
VERONESE
*Venus and
Adonis.* A late
work

painting, originated by Titian, in which the figures, although apparently seen from below, are not fully foreshortened but shown at an angle of forty-five degrees, so that a *di sotto in su* (from below to above) effect is achieved, without loss of narrative clarity or decorative cohesion of the surface.

To Veronese, as a decorator, this coherence of surface was all-important. The harmony and richness of his compositions come not only from the arrangement of the forms but from the balance and interrelation of colours, extending over the whole canvas and woven together into a pattern. In the detail of the *Ill. 126 Adoration of the Magi* in the National Gallery, London, we can see how he matches colours with their complementaries – crimson-red against dark green, pink against emerald – and how the warm brown of the ground makes the blue sing, and is tinged with orange by reaction against it. Through Veronese's understanding of the interaction of colours even the neutral areas take on a tint and the whole surface becomes vibrant.

Colour indeed has in Veronese's paintings a life of its own. His vision is permeated through and through by the movement and atmosphere of the city he adopted. The fluid trails and coagulated pools of paint exist as themselves, as well as the thing they represent, and the dancing interaction of the fluid shapes recalls the play of reflected colour in the Venetian canals as, broken up by the movement of the water, the images of reflected objects dance and fuse together in rippling patterns of colour.

The decorative values in Veronese's paintings suggest the need of a wider field than the individual canvas, and he in fact worked on two decorative schemes: one in the Church of S. Sebastiano in Venice (1555–61) and one in the Villa Barbaro at Maser (c. 1561). In the latter he worked, for once exclusively in fresco, in spaces provided by the measured architecture of Palladio, and the scheme has a coherence unique in Venetian art up to that time. Some of the frescoes are allegorical, but others are without literary content. They are simply landscapes or illusionistic caprices, like the domestics glimpsed through an *Ill. 132* imaginary door. Silvery in tonality, gracious and gentle in feeling, they wonderfully extend Palladio's architecture without destroying its harmony. Although not followed up by Veronese, this style was carried on in other Venetian villas by his pupil Battista Zelotti (1526–78).

In his later painting Veronese follows Titian and Tintoretto in a growing interest in effects of light, although he never allows chiaroscuro to subdue colour. His colours, without loss of richness or saturation, become less bright, more modulated, and more emotive. Landscape also begins to play a larger role in his painting, and in a series of mythological paintings he finds his own landscape ideal: a pastoral richness, as of an enchanted garden, which is as civilized and sophisticated as his figures. These scenes, which mostly concern the love of the gods, are set in a magic twilight, and perhaps it is the fleetingness of this magic light which gives them, in spite of their visual luxury, a tremor of mortality which is near to tragedy.

A comparable depth of feeling is present in Veronese's later religious paintings. In the night scene of the *Agony in the Ill. 135* *Garden* in the Brera, Milan, the landscape is painted in elusive tones of smoky blue, and Christ and the Angel are illuminated by a single shaft of light which, in terms of the paint surface, is also a solid wedge of impasted cream paint. Colour and paint do not lose their decorative value, but they become the instruments for a new depth of emotional expression, as, through light, Veronese's colour becomes more resonant and mysterious. The understanding of the decorative and emotional possibilities of colour which reaches its height in these later works was to be of profound importance to all future European colourists, and most particularly to Delacroix and Cézanne. It also provided an example which was to be the central factor in the final flowering of the Venetian school in the eighteenth century.

135 PAOLO VERONESE *Agony in the Garden*

The seventeenth and eighteenth centuries

Although it is at the moment fashionable to cry up Venetian painting of the seventeenth century, there is little doubt that it was a period of recession, not to say decline. An immense amount of painting continued to be produced, but there was a decline in quality and it is notable that little of what was produced in Venice in the seventeenth century is actually looked at today, even by an informed visitor. Who but the specialist has examined the vast painting by Antonio Zanchi of *Venice delivered from the Plague* on the staircase of the Scuola di S. Rocco, or the immense scenes of the life of S. Lorenzo by Antonio Belucci and Gregorio Lazzarini in S. Pietro di Castello? Such paintings, both in acreage and in artistic poverty, confirm the judgement above. Only a few works and a handful of artists are of significance, and most of these are foreigners who came to Venice from elsewhere.

During the first part of the century the traditions of the later sixteenth century were continued. The workshop of the Bassano family carried on until the mid seventeenth century, and Il Padovanino, until his death *c.* 1650, produced ham-fisted pastiches after Titian. Palma Giovane, who had worked with Titian in his last years, is the most considerable artist of the period, ·practising in a style in which the fluent, painterly manner of Tintoretto is mixed with a vein of Bassanesque realism. Palma was, as the illustration shows, a highly accom- *Ill. 138* plished painter, capable of considerable vigour of execution, but the essential repetitiveness of his work leads rapidly to boredom. The only other painter of significance in this period is Pietro il Vecchio, who gets his name from his deliberate imitations of sixteenth-century masters, especially Giorgione –

169

imitations which unwary critics and over-confident owners often attribute to Giorgione himself.

The poverty of native Venetian painting in the seventeenth century is relieved by the presence of three truly inventive artists who were not Venetians. They are Domenico Fetti (*c.* 1589–1624), Bernardo Strozzi (1581–1644), and Jan Liss (or Johann Lys; *c.* 1595–1629/30), all of whom settled for varying periods of time in the city and absorbed her stylistic traditions. In their painting, Venetian qualities of paint and colour are revitalized by contact with what was going on outside Venice, and appear in a far more lively and up-to-date form than they do in the pastiche styles of local artists. The work of these foreign residents plays an important part in keeping the Venetian traditions going between the decline of local talent at the end of the sixteenth century and the resurgence of originality in native Venetian art which occurs around 1700.

137 BERNARDO STROZZI *St Lawrence giving Alms*

138 PALMA GIOVANE *Self-portrait*

Fetti, who was born in Rome, settled in Venice in 1621 after being Court Painter at Mantua. There he was familiar not only with Elsheimer and Rubens, who are important influences on his art, but also with the paintings of Titian and Tintoretto in the Mantuan Ducal Collection, so that the 'Venetian-ness' of his style partly precedes his arrival in Venice itself. Qualitatively his most important works are small, and the illustration shows how, on a miniature scale, he could reinterpret a composition by Tintoretto (his *Flight into Egypt* in the Lower Hall of the Scuola di S. Rocco) in the manner of Elsheimer, with a juiciness of paint and a softness of colour which are all his own. This softness is important, for it fuses together the broad planes of colour set one behind another in depth, which were typical of Venetian sixteenth-century painting and gives his works a spatial continuity which is essentially Baroque.

Ill. 136

171

136 DOMENICO FETTI *Flight into Egypt*

Fetti also evolved a rather fanciful type of religious genre painting, retelling the Parables in a semi-modern manner with rough picturesque figures, which show his debt to the Bolognese painter Crespi. These scenes are by no means straightforward in mood and anticipate Daumier in the emotive effects of scale created by silhouetting the figures against tall buildings. Such works probably influenced Bernardo Strozzi, a Genoese, who was in Venice from 1630, his forty-fifth year, until his death in 1644.

Strozzi's paintings speak the international language of post-Caravaggiesque realism, and the figure of a peasant on the right of his *St Lawrence giving Alms* is reminiscent on the one hand of Ribera and on the other of Jordaens. He is the first to practise this style of realism in Venice, and the tight, crusty brush-work with which he precisely describes volume and texture was to be an important influence on Venetian eighteenth-century painting, especially on Piazzetta and Tiepolo.

Ill. 137

On the other hand Strozzi's sense of colour and his expression of space owe much to his adopted city. Where but in Venice would he have achieved the marvel of the silver incense-burner which, with the rough, warm hand beneath it, glows dully against an indigo sky crossed by violet clouds? This is an elaboration of the kind of visual experience first recorded by Titian, when he painted the hand against the sky in the background of the lower group in the *Assumption*.

Jan Liss, born at Oldenburg in Germany in about 1595, was in Venice by 1621 and died there of the plague in 1629 or 1630, when still a young man. In some ways he is the most original of all the foreigners who settled in Venice and might, if he had lived, have advanced the development of her style towards a Rococo idiom by half a century. As it was, his Venetian works, of which *St Jerome sustained by Angels* in S. Nicolò dei Tolentini is an example, have a freedom of brush-work, a rhythmic exuberance of paint, and a creamy softness of colour which anticipate the eighteenth century and certainly influenced the colouristic style of Tiepolo.

Ill. 140

139 FRANCESCO MAFFEI *Tobias and the Angel*

140 JAN LISS *St Jerome sustained by Angels c.* 1627

More immediately Liss influenced the Vicentine painter Francesco Maffei (*c.* 1600–38), whose *Tobias and the Angel* in SS. Apostoli shows fairly obviously the effects of his style. Attempts have lately been made to build Maffei into a great painter, but although he handled paint with a great deal of dash and freedom and had an individual sense of smoky colour, his flickering brush-strokes too often fail to cohere into a convincing image, and his style is at worst merely exaggerated, pushing to extremes the mannerisms of Jacopo Bassano and Tintoretto, without any real understanding of the optical basis for their treatment of colour and form.

Ill. 139

Of the other artists working in Venice at this period, the Florentine Sebastiano Mazzoni (d. 1683/5) is the most original.

173

141
SEBASTIANO
MAZZONI
*Apollo and
Daphne*

He had a feeling for paint akin to Maffei's, and a passion for *di sotto in su* effects which makes his rather eccentric paintings *Ill. 141* (notably a series in S. Benedetto), energetic, if over-exaggerated. A visitor of a different kind is the Neapolitan, Luca Giordano, who in 1685 was commissioned to paint three altarpieces in S. Maria della Salute. Giordano's High Baroque manner shows, in its fluidity and luminosity, the effects of the Venetian tradition, and his altarpieces reintroduce into Venice in an up to date manner the very qualities which had made her painting influential. His works are the most important instance of that feedback which begins to overtake painting in Venice towards the end of the century, and play an important part in the revival of Venetian art which, under the leadership of Sebastiano Ricci, took place at the beginning of the new century.

The reason for the final flowering of Venetian art in the eighteenth century at a time when politically the Venetian State was in the penultimate stage of its decline is something of a mystery. The phenomenon is a warning against any easy equation between periods of political and social expansion and periods of artistic achievement, and suggests how complex the interrelation between the history of the arts and the history of their social and political environment really is. All that we can say is that, for all the decline of her political power, immense wealth still existed in Venice, and traditions of patronage, both public and private, going back to the fifteenth century made the commissioning of works of art a natural source of prestige. In a period when wealth was changing hands and passing from old patrician families to the *nouveaux riches* anxious to establish themselves, this patronage could be of particular importance. There was a growth in ostentation among the old families as well as the new, and the artistic enterprises of the eighteenth century have a scale and dazzle which are designed for display, and seem to reflect a frantic search for reassurance.

In a city drained, in public and private life, of real creative energy, such needs could hardly have been so brilliantly met had it not been for the artistic traditions of the Venetian past to which the artists of the new generation could return for inspiration. Venetian painting in the early eighteenth century turns gradually back from the eclecticism of the preceding century to the colouristic and painterly values of its own finest period, seeing them, however, through the medium of the European Baroque which Venetian artists had absorbed from outside in the preceding decades. In the work of two artists of genius, Tiepolo and Piazzetta, and of a number of considerable lesser figures, all the essential qualities of the Venetian school are reasserted and re-expressed in the more fluent and spacious idiom of the new century.

But at the same time the social decline of the city and the artificiality of its values do, at the deepest level, seem to have affected this final phase of its art. For all its brilliance, Venetian

175

art of the eighteenth century seems distanced from reality. This is true even in the work of Tiepolo who, in spite of his range and vigour, his power of visual observation and his human sympathy, seems to see the world as through a veil. The ultimate human impact of his work is muted and the demands of style impose a uniformity which is artificial. For all its greatness, the art of the Venetian eighteenth century is in the truest sense of the word decadent: not life-assertive and concerned with passion, but withdrawn into its own conventions and therefore in decline.

Sebastiano Ricci (1659–1734) is the key figure in the revival of Venetian art, and his historical importance has sometimes led to the over-estimation of his artistic qualities. Born in Belluno, which had been under Venetian rule since the fifteenth century, he was trained in Bologna and did not make Venice herself his home until he was over forty. Having painted in, among other places, Parma, Pavia, Milan, and Rome, he had an eclectic acquaintance with the Baroque and it was this international vocabulary which he fused with the native Venetian tradition in the works he painted in Venice. In his three paint-

Ill. 147 ings for the ceiling of S. Marziale, painted *c.* 1705, exuberantly floating forms of a fluidity and charm going back through the Baroque masters to Correggio are painted with a luminosity of colour already characteristically Venetian. These paintings matched in their brilliance the altarpieces painted by Giordano for the Salute, and established Ricci as the leading local painter.

Ill. 142 In 1708 he painted the *Madonna and Child with Nine Saints* in S. Giorgio Maggiore which shows the essential debt of the new style to Veronese – it is plainly influenced by the composition of Veronese's famous *Marriage of St Catherine* – but has other qualities which are typical of the eighteenth century. The weight and solidity of Veronese's group is attenuated to a lighter, looser arrangement, with a larger proportion of open space and more angular, elongated forms. The gambolling *putti* already strike a note of Rococo frivolity and the expressions of the saints are sentimental rather than serious or profound.

176

142 SEBASTIANO RICCI *Madonna and Child with Nine Saints* 1708. Still on the altar in S. Giorgio Maggiore for which it was painted

143 SEBASTIANO RICCI *Marriage Feast at Cana*

These are the qualities of the new century as a whole, and they can be seen also in another, still more obvious pastiche after Veronese: Ricci's *Marriage Feast at Cana*. *Ill. 143*

This painting also shows Sebastiano's comparative weakness as an artist, relative to the great masters like Veronese and Tiepolo who precede and follow him. His rather sharp colours never fuse together into a whole, so that the effects in his display-pieces are edgy rather than opulent; and the brush-work, although free and sparkling in his small-scale studies, often becomes mannered in his larger works. Emotionally and formally there is a certain dryness about his art which repels even while his technical qualities excite admiration.

144 GIOVANNI ANTONIO
PELLEGRINI *Martyrdom of St
Andrew* 1721. One of a
series of scenes of
martyrdoms in S. Stae on
which most of the leading
Venetian painters
collaborated

146 JACOPO AMIGOÑI ▶
Justice 1728. Ceiling panel
from an ante-chamber in
the Monastery of
Ottobeuren

145 PELLEGRINI *Triumphal
Entry of the Elector Johann
Wilhelm of Palatine* 1713–14

This is not the case with his follower G. A. Pellegrini (1675– *Ills. 144–5*
1741), whose frank delight in delicious, soft colours and fluent
brush-work anticipates Fragonard. Pellegrini was Venetian-
born, and his starting-point is the art of Ricci, but he painted
hardly at all in Venice; from 1708 – when he first went to
England with Sebastiano's brother Marco Ricci – he travelled
around the courts of Europe painting decorative schemes, often
on a large scale; of which that painted for Schleissheim, the
palace of the Electors of Bavaria, is a typical example.

At this period – the first three decades of the eighteenth
century – all the leading Venetian artists (including Sebastiano
himself, who was in England from 1712 to 1717), travelled,
and the international success of their type of Venetian painting

in northern Europe shows how well its light brush-work and airy effects were adapted to Rococo taste. That it reflects the same preoccupations as the new style of Rococo architecture which was being created simultaneously in Bavaria is shown in the decorative painting of another peripatetic Venetian artist, Jacopo Amigoni (1682–1752), who likewise painted in England and for the courts of Germany. His work has a spaciousness, a softness of light, and a pastoral charm which reflect a wealth of influences from the Venetian past – from the Bassani not less than from Veronese – all translated into a later, more gracious idiom. In his decorative panel for the ceiling in the entrance to *Ill. 146* the Abbot's rooms at Ottobeuren, painted in 1728, the softly-coloured forms are set airily, in a typically Venetian manner, against a delicately modulated atmospheric space, but also harmonize perfectly with the stucco decoration of the ceiling. The success of Venetian painters in such commissions show their professionalism and adaptability, but the city seems to have been resistant to the extreme lightness and frivolity of this style; the followers of Ricci received few commissions in Venice herself. The new decorative painting fully established itself in the city only during the mid thirties with the success of Tiepolo, whose art is more grand and severe than that of his slightly older contemporaries.

In the Veneto, however, this style continues into the middle of the century in the religious works of the brothers Guardi: Francesco (1712–93), whose more familiar work as a view painter will be dealt with later in the chapter, and Gianantonio (1699–1769). The nature of their collaboration is not wholly clear, but it is probable that Gianantonio was the dominant figure in the religious paintings from their workshop, including a number of altarpieces for parish churches in Friuli and the *Ill. 149* Veneto, some of which he signed. These developed Sebastiano Ricci's sparkling brush-work to a degree of independence which is highly mannered, scattering explosive white high-lights like sparkler fireworks over the whole surface of the painting.

147 SEBASTIANO RICCI
*The Miraculous Arrival
of the
Statue of the Madonna*
c. 1705

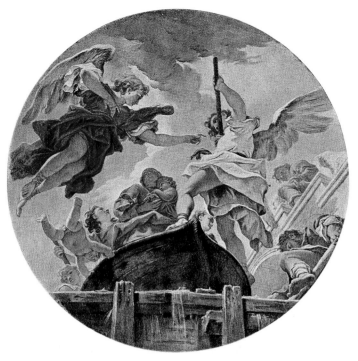

148 GIANANTONIO and FRANCESCO GUARDI
Tobias fishing

149 GIANANTONIO GUARDI
*Madonna and Child with
Six Saints* 1746

151 GIOVANNI BATTISTA ▶
PIAZZETTA *Ecstasy of St Francis*
1732

152 GIOVANNI BATTISTA
PIAZZETTA *Virgin and Child with
Saints* 1744. The high altar of a
remote parish church in the
foothills of the Alps which is
often surrounded by swirling
mists like those in the painting

150 (*below*) GIOVANNI BATTISTA
PIAZZETTA *Rebecca at the Well*

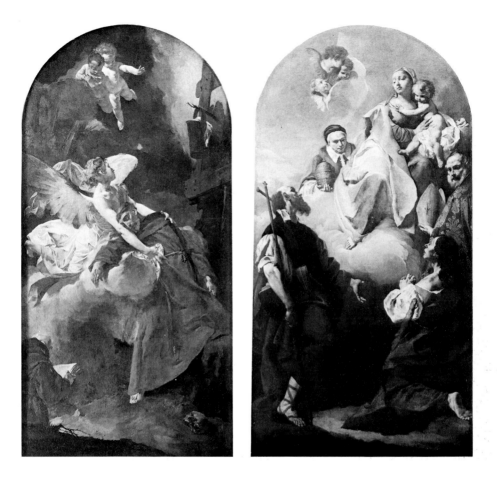

The most accessible works in this style are the scenes from the story of Tobias which form the organ frontal in the Church of the Archangel Raphael in Venice itself. Here the free brush-work and soft, changing colours conjure up fairy-tale vistas – mountains glimpsed across lagoons, piles of operatic drapery, and fragments of architecture – with so atmospheric a sense of colour and so imaginative a fantasy that it seems as if Renoir has turned his hand to designs for the Sleeping Beauty. These scenes avoid the mannered repetition of bravura effects of brush-work which mar the altarpieces, and the close observation of nature which lies behind the fantasy is usually thought

Ill. 148

183

to reflect the collaboration of Francesco Guardi with his brother. The paintings represent the most extreme manifestation within the city itself of that virtuoso style of painting which Sebastiano Ricci had initiated in the first decades of the century.

The second stream of Venetian painting in the eighteenth century, which was to unite with that of Ricci only in the work of Tiepolo, originated in the second decade. G. B. Piazzetta (1683–1754) was its leading master. In the context of Venetian eighteenth-century art as a whole Piazzetta is an outsider. In an age which laid stress on brilliance of effect and facility of execution, he was a slow worker, and his melancholic temperament, noted by his contemporaries and friends, shows itself in the passion of his religious paintings and the subjectivity of mood in his pastoral pieces. His is an intense and introverted art.

Piazzetta's historical importance lies in his fusion of a Venetian feeling for paint with the dramatic chiaroscuro and tactile realism of the tradition of Caravaggio. The forms in his painting have a palpable reality of texture which he must have learned partly from Bernardo Strozzi, but they are created with a marvellous fluidity and freedom of brush-work which belongs in kind to the traditions of the Venetian sixteenth century.

The spiritual intensity of Piazzetta's painting comes from the combination of this physical realism of detail with the visionary effect of the whole. In his painting in the Parish *Ill. 152* Church of Meduno, the Virgin, floating on clouds, is thrust forwards towards the spectator, while below her, and between the foreground figures, a dizzy vista of swirling mist opens to the distance. Through the closeness of the figures and his observation of natural effects of space, Piazzetta gives a new reality to the dynamic involvement of the spectator in the work characteristic of Baroque composition, and the association of the Virgin with the drama of clouds, mist, and vertiginous

184

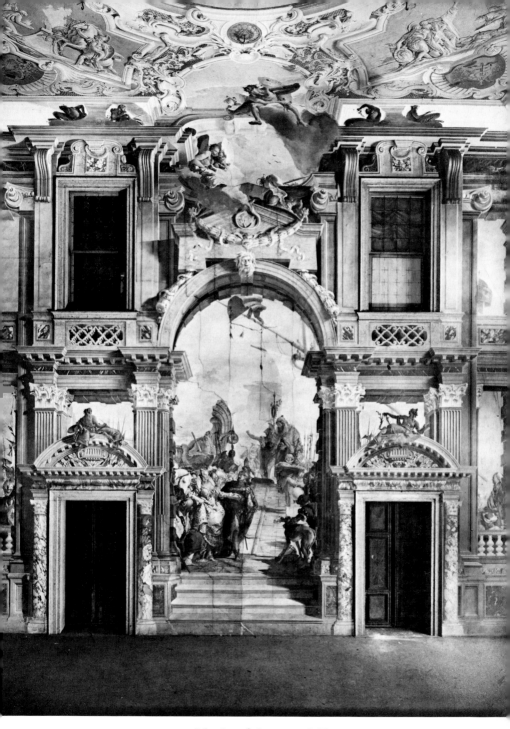

153 GIOVANNI BATTISTA TIEPOLO *Meeting of Antony and Cleopatra* 1745–50

mountain vistas gives her an elemental power rare in eighteenth-century art. By combining this with an aristocratic hauteur more typical of the period, Piazzetta creates a religious image all his own.

Ill. 151 The *Ecstasy of St Francis* at Vicenza shows the same qualities. The kneeling monk in the foreground ushers one into the painting, and the dramatic use of light and shade is no less spiritual in effect because it is based on observable effects of stormy light. Indeed the humble bucket seen against the strongly-lit clouds is in some ways the most dramatic, even the most spiritual thing in the painting. The hand of the Saint against the sky emerges as a palpable form in space largely in terms of the white highlights against the warmer tones behind, and reminds one, in its economy of brush-work and vivid immediacy of visual impact, of Tintoretto.

Piazzetta also painted a number of pastoral subjects, in which large, rather grand figures are monumentally grouped in the open air. Old Testament scenes with a pastoral flavour, such *Ill. 150* as *Rebecca at the Well*, were popular in Venice in the early eighteenth century – Pellegrini painted a number – but only Piazzetta's have this solemnity of mood, which comes from the dramatic lighting, the placing of the figures against open sky, the intensity of their glances, and the obsessive focusing on details. Piazzetta also painted pastoral scenes for their own sake (for example paintings at Cologne and in the Accademia, Venice) and in his emotionally-heightened treatment of such subjects, as in many other areas, he anticipates his spiritual heir, Giovanni Battista Tiepolo.

Tiepolo, who was born in Venice in 1696, was trained in the studio of the history painter Gregorio Lazzarini, but the vision of nature in his early paintings comes from Piazzetta. In the *Ill. 154* early *Rape of Europa* in the Accademia in Venice an extensive landscape, both mysterious and real, is created by Piazzetta's method of scumbling cool bluish tones over a warm ground and establishing the highlights in fluid areas of white. No other Venetian artist except Piazzetta or Tiepolo could, in the

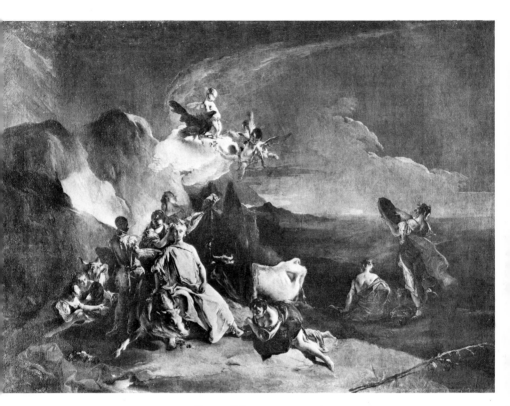

154 GIOVANNI BATTISTA TIEPOLO *Rape of Europa c.* 1725–6

eighteenth century, have created the reality and drama of space and atmosphere in this painting; and yet Tiepolo is already showing his Rococo leanings in the smallness of the figures *vis-à-vis* their surroundings, and in the way in which the fluttering movements and gestures pick one another up across the empty space of the painting and articulate the whole area of the canvas. Here a compositional tradition stemming from Sebastiano Ricci is combined with the vision of Piazzetta to become the basis of a new style, more decorative but also more closely based on the observation of nature than had existed in eighteenth-century Venice before.

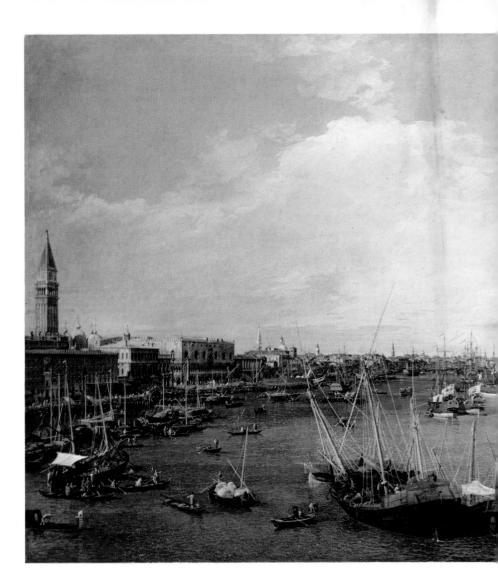

As a decorative artist Tiepolo's first achievement was to graft a colouristic style of painting, derived in principle from Veronese, on to the tradition of illusionistic perspective in ceiling decoration which derived from Rome, and especially from the Bibiena family. In the early 1720s he collaborated with Girolamo Minguzzi Colonna (a follower of the Bibiena)

155 CANALETTO *Bacino of S. Marco*. One of Canaletto's largest and most magnificent panoramas

on the ceiling the *Apotheosis of St Theresa* in the Scalzi, which in its turn influenced Piazzetta's only ceiling painting, the *Glory of St Dominic* in SS. Giovanni e Paolo; the same influences are to be felt in another remarkable piece of illusionism: the Chapel of the Blessed Sacrament in the Cathedral at Udine, which he was called to decorate in 1726.

156 GIOVANNI
BATTISTA TIEPOLO
Angels from the
frescoes which
decorate and
transfigure the walls
of the Chapel of the
Sacrament in the
Duomo, Udine,
1726–8

Ill. 156 At Udine, by an equivalence of tone between the real and
the painted architecture, the angels, luminously painted in
fresco on the walls, seem to float free of the sides of the chapel,
and the whole space is irradiated by the light evoked around
them. Real and simulated light, painted figures and real archi-
tecture create together an effect of breathless adoration focused
on the Sacrament itself. Such an all-embracing reality of light
and air had scarcely been achieved before in illusionistic painting,
and in this respect the closest parallel to Tiepolo's achievement
is in the frescoes painted some seventy years later by Goya
round the dome of S. Antonio de la Florida in Madrid:
themselves influenced by Tiepolo's later work in that city.

While in Udine Tiepolo also decorated the galleries of the
Archiepiscopal Palace with scenes from the Old Testament,
and it was in these scenes that, in colour and conception, his
decorative ideas reached their maturity. The strong chiaros-
curo of Piazzetta was abandoned for a lighter palette in which

delicate pastel shades were balanced and mingled one with another in broad, bland harmonies. The principle of these interwoven colour-relationships came, of course, from Veronese, but the pastel colours were Tiepolo's own, and the new lightness and spaciousness which entered his painting at this time was perhaps a direct response to the beauty of the open, softly-coloured landscape of the Alpine foothills around Udine, *Ill. 158* which seems to have been a catalyst for Tiepolo in the same way as was the landscape of Provence for Van Gogh. Delicately observed details from this landscape form a background to many of the scenes in the Archiepiscopal Palace, and indeed recur in many of his later works.

His treatment of the Biblical scenes themselves shows the depth of Tiepolo's human sympathy. We can see it in the unbelieving gesture with which the toothless Sarah receives *Ill. 157* the Angel's announcement that she is to bear a child. But the

157 GIOVANNI
BATTISTA TIEPOLO
*The Angel visiting
Sarah* 1725–6.
From the gallery
of the patriarchal
palace at Udine

aristocratic refinement of Tiepolo's style results also in a curious muting of dramatic values. The artist is a master of elusive mood, and often his bowed, languid figures seem to belong not so much to a narrative as to a moment of heightened intensity treated for its own sake. This is literally true of the engraved *capricci*, which have no subject but are quintessentially Tiepolesque in their highly charged but motiveless intensity. Such works are a long way from the robust vigour of sixteenth-century Venetian painting: they have an air that is unmistakably *fin de siècle*.

As a decorator, Tiepolo knew well how to satisfy the needs of his patrons, and his magniloquent ceiling paintings for the palaces of Venice and other North Italian cities achieved a popularity which had been denied, in Venice herself, to the *Ill. 159* followers of Ricci. The ceiling of the Ca' Rezzonico in Venice is a typical example of his ability to handle large spaces lightly and with convincing illusionism, creating grand ensembles which glorify the patron by flattering analogies between the

158 GIOVANNI BATTISTA TIEPOLO Detail of landscape from *Rachel hiding the Idols*

159 GIOVANNI BATTISTA TIEPOLO *Marriage of Ludovico Rezzonico and Faustina Savorgnan* 1758. The palace of the Rezzonico family of which this is a ceiling was designed by Longhena *c.* 1667 and is one of the most extravagant of Venetian palaces

histories of his family and those of the Antique gods. Similarly, in the scenes in the Palazzo Labia Tiepolo developed to its limit that illusionistic, decorative style which Veronese had practised in the Villa Maser, re-evoking, with the greater refinement of a less robust age, his ideals of magnificent living. *Ill. 153*

It was chiefly his facility as a decorator that gave Tiepolo his international fame. From 1751 to 1753 he worked on the new Residenz of the Prince-Bishops of Würzburg, collaborating with the architect, Balthazar Neumann, on two decorative schemes which, in their solidity and magnificence, contrast

Ill. 146 with the lighter, more frivolous decorations of Amigoni at Ottobeuren in the same way as the architecture of Fischer (who built Ottobeuren) contrasts with that of Neumann. Tiepolo's other great project abroad was the decoration of the Guard and Throne Rooms in the Royal Palace at Madrid, which he undertook unwillingly in 1761, at the very end of his life.

Tiepolo's range is that of a Renaissance artist and his religious works, whether altarpieces or cabinet paintings, are at least as important as his grand decorative schemes. They give a spiritual dimension to his art which is sometimes neglected. In these works he shows himself as a classical artist, constantly refining and clarifying his original conception; and behind the

Ill. 160 monumentality of the massed forms in his *Road to Calvary*, where all attention is concentrated on the triangle round the fallen Christ, lies a much less highly-organized oil-sketch, which formed the starting-point for the final composition.

Within the ordered monumentality of his large religious works Tiepolo none the less includes passages of direct observation, such as the snow-covered mountains in the background of the *Road to Calvary*, which are almost topographical in their realism, and in their precise observation of tone anticipate Corot. Such details point to the ambivalence of Tiepolo's position, standing at the end of one tradition and at the beginning of another. The freshness of which, in his observation of landscape, he was capable is nowhere more apparent than in the small cabinet pictures he produced at the very end of his life, when he was in Spain. In his late *Flight into Egypt* the figures are dwarfed by a landscape of lonely vastness, and the open spaces hitherto articulated by *putti* or angels are traversed now only by swooping birds. These pictures seem to show the impact of the Spanish landscape on Tiepolo's imagination and reveal that continuing dialogue with nature which distinguishes his work, in kind and quality, from the decorative manner of his contemporaries.

Yet when this is said it must be admitted that the element of 'manner' in Tiepolo's art is far stronger and more self-

194

160 GIOVANNI BATTISTA TIEPOLO *Road to Calvary* 1740. The central canvas
of three scenes of the Passion in the apse of S. Alvise

conscious than in the masters of the sixteenth century. The
very facility with which he worked – the calligraphic precision
of his brush-work and the crusty texture of his surfaces –
distances his painting from reality and subdues all the elements,
even passages of direct observation and the most profound
feeling, to the ultimate demands of style. In the last resort
Tiepolo's paintings lack passion and, for all their brilliance and
range, are the works of a great artist held in by an artistic
tradition in decline.

161 GIAN DOMENICO
TIEPOLO *Il Riposo di
Pulcinella* 1758

162 PIETRO LONGHI
*Arrival of the Padrone at
his Country Estate*

163 PIETRO LONGHI *The
Rhinoceros* 1751.
Inscribed 'True likeness
of a rhinoceros brought
to Venice in 1751'

One painter of religious and history pictures, G. B. Pittoni (1687–1767) enjoyed in his own day a popularity comparable to that of Tiepolo. His style was less classically orientated than that of his greater rival, even though he rather specialized in scenes from ancient history, and in composition and handling it belongs to the Rococo tradition of Ricci. The facility and flourish of his pictorial effects do not, however, disguise a rhetorical exaggeration which makes his work for all its grandiloquence, essentially frivolous.

Gian Domenico Tiepolo (1727–1804), Giovanni Battista's son, worked throughout a large part of his life as an assistant and partner to his father, accompanying him, for example, on his journeys to Würzburg and Madrid. As an independent painter of religious paintings Gian Domenico's style is very close to his father's, although he lacked the latter's supreme feeling for decoratively interwoven colour. He is at his most original as an etcher, finding new ways of combining figures

196

and landscape in his *Picturesque Ideas on the Flight into Egypt.*
Gian Domenico also showed his originality in two series of
frescoes: the first for the Garden Pavilion of the Villa Val-
marana near Vicenza – where Giovanni Battista was painting
at the same time – and the second (now in the Accademia)
for his own home. They are quite different from anything
painted by his father, and show scenes of contemporary life,
whose bucolic humour has a sharply satirical edge. Through
dramatic effects of space and atmosphere they too achieve an
unexpected profundity. The scene of *Il Riposo di Pulcinella* has a *Ill. 161*
scale and grandeur of form which had hitherto belonged chiefly
to monumental painting but is here applied to macabre figures
from the Commedia dell'Arte. Painted in low tones of grey and
white, this picture, with its giant masked figures towering
against the sky, is very disturbing and has something of that
sinister universality which we find at the end of the century in
Goya's treatment of contemporary subjects.

No such intention is to be attributed to the only other significant genre specialist in eighteenth-century Venice, Pietro Longhi (1708–85). His conversation pieces and cabinet-sized scenes of contemporary life follow the general taste of the century, but with a nice sense of significant composition and a refined feeling for atmosphere that goes beyond any-thing in the works of his northern contemporaries. In the *Ill. 163* famous scene of Venetians contemplating a rhinoceros, the picture owes its charm to the expressive way in which he has divided the composition, filling the lower half with the large and uncompromising bulk of the animal, which is contrasted, in its solid ugliness, with the elongated pyramid formed by the slight, doll-like figures who look down on him. Through the arrangement of the picture and the character of the forms themselves Longhi is making a comment beyond merely descriptive reporting.

His art, though satirical in a gently humorous way, is free from any hint of serious social criticism and, like the plays of his admirer Goldoni, was very popular with the society it portrayed. Longhi's training as a genre painter was in Bologna under the Caravaggiesque G. M. Crespi, whose influence is to be seen in his painting of the Seven Sacraments as everyday scenes; but he has a Venetian feeling for diffused effects of light which is apparent in such scenes as the *Arrival of the Padrone* *Ill. 162* *at his Country Estate*, now in the Querini Stampalia Gallery at Venice. The sense of place and time, the physical and psycho-logical feel of the occasion, are here very precisely rendered, with a sense of space and atmosphere worthy of Piazzetta himself.

In landscape as well as genre, the contribution of the city's artists is closely related to what was going on elsewhere in Europe, but is also markedly individual. The strain of ideal pastoral landscape, which had originated in Rome, was brought to Venice by the Florentine Francesco Zuccarelli (1702–88) in about 1733, and under Venetian influence became more painterly, frivolous, and light-hearted, with fuzzy atmosphere

198

164 GIUSEPPE ZAÏS *Landscape with Washerwomen*

and an added spaciousness in the central vista. These qualities
can be seen in the work of Giuseppe Zaïs (1709–84), a Venetian *Ill. 164*
influenced by Zuccarelli, who, with an eclecticism characteristic
of the period, mingled the influence of the Florentine painter
with those of Dutch landscape and Marco Ricci. Ricci him-
self (1676–1730), the brother of Sebastiano, had visited Rome
and seems to have been influenced by the paintings of Salvator
Rosa and his eighteenth-century follower Magnasco. The
latter's somewhat exaggerated view of the drama of nature
in the raw, which was expressed through scenes of monks and
bandits in landscapes of fantastic wildness, seems to have made
a deep impression on Marco Ricci, but he applied it, as Pallu-
chini has suggested, rather through the drama of nature herself
than through the kind of romantic figure subjects which
Magnasco loved. This can be well seen in his *Seascape* in *Ill. 165*
the Museo Civico, Bassano, in which the painterly handling of
Magnasco is applied with a Venetian breadth of atmosphere to a
natural subject dramatic in itself.

165 MARCO RICCI *Seascape*

Marco Ricci was a master of the *capriccio*, an imaginative arrangement of ruins in a landscape, designed to create a romantic effect; his earlier scenes in this genre show very solid Roman ruins, rather conventionally put together, in which the effect of the buildings is everything and there is little concern with space. Once again, however, this style is modified under the influence of the traditional artistic concerns of Venetian *Ill. 167* art, and the *capriccio* illustrated has a spatial excitement, conveyed through the dramatically sliding perspective, the softness of tone, and the subtlety of enveloping atmosphere, which is quite un-Roman: so much so that, although the painting is usually attributed to Marco Ricci, it has also been suggested that it may be the work of the young Canaletto.

Both Canaletto and the brothers Ricci, as well as many of the other leading artists of the day, including Piazzetta, worked

166 SEBASTIANO RICCI *Memorial to Sir Clowdisley Shovell*
167 MARCO RICCI or CANALETTO *Capriccio*

on a series of novel and highly specialized *capricci* which were
commissioned at this time by the Irish businessman and
speculator in art, Owen McSwiny. They represented imagi-
nary tombs for famous Englishmen and were designed, of
course, with British patrons in mind. However, in practice,
their subjects are little more than an arrangement of elegant
ruins, picturesquely peopled by vaguely symbolic figures;
but, commissioned by foreigners for foreigners, they show the
extent to which Venetian art had become, by the mid eighteenth
century, a commodity primarily for export. In this area the
most important exporter was undoubtedly the English Consul,
Joseph Smith, resident in Venice from the early years of the
century, and the most important goods to be exported were
topographical views of the city itself, the chief painter of which
was Canaletto.

201

As we have seen, the tradition of topographical view painting goes back in Venice to the backgrounds of the narrative cycles made for the Scuole. Luca Carlevaris (1665–1731), a native Venetian, took up this tradition in the early eighteenth century, producing a number of paintings in which the bustle of city life is as important as the view. Some of these were commissioned to record a specific event, and ceremonial functions and the many festivities of the Venetian calendar remained an important element in topographical painting, not least in the works *Ill. 170* of its two greatest masters, Canaletto and Francesco Guardi. Canaletto (1697–1768), apart from some occasional work as a painter of *capricci*, practised almost exclusively as a view painter, and the majority of his pictures went abroad, so that to this day few of his paintings are to be seen in Venice. From about 1730 he had a working arrangement with Consul Smith which led,

168 CANALETTO *The Stonemason's Yard*

169 CANALETTO *S. Giuseppe di Castello*

between 1746 and 1756, to lengthy visits to England; yet he is anything but a hack artist and, within their circumscribed subject-matter, his paintings reflect the workings of a profound visual sensibility on the main preoccupations of the art of his day.

His early views, which date from the 1720s, are free and painterly in handling, with delight in the picturesque texture of surfaces and strong contrasts of light and dark. As such they parallel, in their own terms, the work of Piazzetta, and when, in the next decade, Canaletto develops away from chiaroscuro towards an all-over luminosity and an even lightness of tone, he is again following the same line of development as Piazzetta's pupil Tiepolo. In his great painting of the *Bacino* (or Pool) *of S. Marco* at Boston, the open arc of space created by the Riva and the Isola di S. Giorgio is lightly articulated by the thin line of buildings and the horizontals and verticals of the masts and hulls of the many boats in the Bacino. The soft pink and blue effect of Venetian light, which is slightly muffled by

Ill. 168

Ill. 155

170 CANALETTO *Regatta at Ca' Foscare* (detail)

mist even on a clear day, is perfectly recorded, and the great
bowl filled with atmosphere is as luminous, light, and spacious as
the ceilings of Tiepolo himself. Canaletto here reveals the most
exquisite sense of spatial control and a sensibility to light of the
highest order.

Ill. 169 This can be seen, too, in such views of the city's squares as
the one illustrated which, in its orderly, rectangular treatment
of space and its precisely organized details, recalls Carpaccio.
By this time Canaletto had developed a very characteristic,
calligraphic type of brush-work which is sometimes regarded
as a mannerism and attributed to a need for speed in execution,
resulting from the pressure of commissions. This may indeed
be one of the reasons for its development, but it also fits well
with the classical discipline of structure in Canaletto's later
paintings, giving a sharpness and precision to the paint surface

204

171 CANALETTO *The Park from Badminton House c.* 1748

which is part of the artistic effect. Canaletto continued to work in this style in England, where he was inspired by the open spaces of English parks and the soft summer light – not altogether unsimilar to that of Venice – to produce some of his best work. *Ill. 171*

His nephew and pupil Bernardo Bellotto (1720–80), some- *Ill. 172* times also rather confusingly known as Canaletto, also travelled in northern Europe, painting in Dresden and Poland. His views are more factual than those of his uncle, with a stronger feeling for picturesque local colour, much less spatial control, and a less sure sense of enveloping atmosphere. For all his anecdotal charm Bellotto is a reporter, whereas his uncle is an artist. The other *vedutisto* of note who emerged from Cana- letto's orbit is Andrea Visentini, who produced for Consul Smith a series of engravings after Canaletto's works.

The last of the great Venetian view painters is Francesco Guardi (1712–93). Although, as we have seen, he first collaborated with his brother Gianantonio on religious paintings, he seems to have turned exclusively to view painting by the mid sixties. Naturally, his early works were partly influenced by Canaletto, but the brothers Ricci were an even more important influence on the formation of his style, and by the time he reached maturity he had moved so far from Canaletto that it is difficult to imagine two artists seeing the same places in a more different way. Whereas after 1730 Canaletto's vision of his native city became increasingly clear and crystalline, Guardi's becomes always more atmospheric and picturesque; the essence of his vision is best summed up by the flickering draughtsmanship of his drawing of a fire at S. Marcuola in which physical substance is reduced to shifting flames.

Ill. 173

Guardi's highly textured views of the city are usually filled with masked or muffled figures, and the very boats on the canals seem eerie and insubstantial. His loose, rather wispy brush-work, which turns figures and buildings into wraiths, derives from the tradition of Magnasco and Sebastiano Ricci, and to a large extent his style is the result of a grafting of their picturesque manner on to topographical subjects.

173 FRANCESCO GUARDI *Fire at S. Marcuola* 1789

Above all he loved scale and distance. When he paints the progress of the Bucintoro on the Feast of the Redentore, he does not, like Canaletto, show it anchored at the top of the Grand Canal, but far out on the lagoons, near the Island of the Lido. The space itself is the main subject of the picture, and the barge and its attendant boats are reduced to a cluster of tiny blobs of coloured paint, dwarfed by the exaggerated perspective of the city and the immensity of the surrounding lagoons.

The lagoons are indeed Guardi's natural subject, forming *Ill. 174* the main imagery for his most original inventions: those landscape 'poesies', half-way between the traditional *capriccio* and the tone-poems of Whistler, which formed such a large part of his output. In these scenes the romantic imagery – ruined towers and drooping fishing-nets – fuses with the blue-grey tones of the lagoons to create paintings of great tonal delicacy, whose poetic mood is tinged with nostalgia. These

207

172 BERNARDO BELLOTTO *Piazza del Campidoglio*

174 FRANCESCO GUARDI *View of the Lagoon*

scenes, and Guardi's views generally, reveal a romantic approach to the city and its surroundings which we have not seen before, so that there is a real sense in which Guardi, although a Venetian born, is the first painter to look at Venice like a tourist. He sees her as a romantic image rather than a reality and, by thus raising her into a creature of the imagination, finally deprives her of life.

Guardi is not only the last Venetian view painter, but also the last major Venetian artist. While, in her intellectual life, Venice played a distinguished part in the Neoclassical movement, her school of painting lost its identity, and the few Venetian Neoclassical painters were hardly Venetian artists at all in the sense in which the term has been used throughout this book. Venetian art ends in 1793 with the death of Francesco Guardi, only four years before the destruction of the Republic itself.

Short Bibliography

Books in English on Venetian painting are not numerous, but the following can be recommended:

GENERAL

B. BERENSON, *Italian Pictures of the Renaissance: the Venetian School*. 2 vols. London 1957. This is an indispensable corpus of plates, with lists of the location of paintings, covering the fourteenth, fifteenth and sixteenth centuries.

B. BERENSON, *Italian Painters of the Renaissance*. London (in various editions with a paperback edition by Fontana). Contains an essay on Venetian paintings, written in 1894, which is still a stimulating introduction to the subject.

L. MURRAY, *The High Renaissance*. London and New York 1967.

L. MURRAY, *The Late Renaissance and Mannerism*. London and New York 1967. Both books contain sections on Venetian art in the sixteenth century.

R. WITTKOWER, *Art and Architecture in Italy: 1600–1750*. London. This has authoritative although rather short sections on Venetian painting in the seventeenth and eighteenth centuries.

M. LEVEY, *Painting in XVIII century Venice*. London 1959.

F. HASKELL, *Painters and Patrons. A Study of the Relation between Italian Art and Society in the Age of the Baroque*. London 1963. Excellent on the social background of seventeenth- and eighteenth-century Venetian art.

MONOGRAPHS

R. FRY, *Giovanni Bellini*. London 1899.

G. ROBERTSON, *Giovanni Bellini*. London 1968.

J. LAUTS, *Carpaccio: Paintings and Drawings*. London 1962.

B. BERENSON, *Lotto*. London 1956.

H. TIETZE, *Titian*. London 1950.

H. WETHEY, *The Painting of Titian I: the Religious Paintings*. London and New York 1969; *II: the Portraits*. 1971; *III: the Mythologies and Historical Paintings*. 1975.

C. HOPE, *Titian*. London 1980.

H. TIETZE, *Tintoretto*. London 1958.

E. NEWTON, *Tintoretto*. London 1952.

A. MORASSI, *Tiepolo*. 2 vols. London 1955 and 1962.

W. G. CONSTABLE, *Canaletto*. 2 vols. Oxford 1962.

V. MOSCHINI, *Francesco Guardi*. Milan and London, n.d.

V. MOSCHINI, *Canaletto*. Milan and London, n.d.

R. PALLUCCHINI, *Piazzetta*. Milan and London, n.d.

T. PIGNATTI, *Pietro Longhi*. London and New York 1969.

GUIDEBOOKS

G. LORENZETTI, *Venice and her Lagoons*. Venice 1956.

H. HONOUR, *Companion Guide to Venice*. London 1965.

In Italian are two works indispensable for their respective periods:

R. PALLUCCHINI, *La Pittura Veneziana del Trecento*. Venice 1964.

R. PALLUCCHINI, *La Pittura Veneziana del Settecento*. Venice 1960.

Also valuable are the Catalogues of the various Mostre, exhibitions of Venetian art and artists held biannually in the city. The following are especially useful:

R. PALLUCCHINI, *Giovanni Bellini*. Venice 1949.

P. ZAMPETTI, *G. Mariacher*, G. M. PILO, *La Pittura del Seicento a Venezia*. Venice 1959.

P. ZAMPETTI, *Jacopo Bassano*. Venice 1957.

P. ZAMPETTI, *Mostra dei Guardi*. Venice 1965.

P. ZAMPETTI, *I Vedutisti Veneziani del Settecento*. Venice 1967.

P. ZAMPETTI, *Del Ricci a Tiepolo*. Venice 1969.

209

List of Illustrations

Dimensions are given in inches and centimetres, height preceding width

210

211

Photographic Sources

Index